Awake!

Keeveeok, Awake!

Mamnguqsualuk and the Rebirth of Legend at Baker Lake

An exhibition held at the Ring House Gallery,
November 20, 1986 to January 11, 1987,
in conjunction with the 25th Anniversary of the
Boreal Institute for Northern Studies.

Published by Boreal Institute for Northern Studies,
University of Alberta.

Financial assistance for the production of this catalogue
was provided by a Special Presidential Grant from
S.S.H.R.C.

University
of
Alberta

Ring House Gallery
University of Alberta
Edmonton, 1986

Canadian Cataloguing in
Publication Data

Mamnguqsualuk, Victoria, 1930-
 Keeveeok, Awake!
 Mamnguqsualuk and the Rebirth
 of Legend at Baker Lake

Boreal Institute
Occasional
Publication
Number 19
ISSN-0068-0303
ISBN: 0-919058-34-5

Design: University Collections
Photography: Lauren Dale
Photography, Edmonton-
cover & plates 1-20;
K.J. Butler - p.4; Ernest Mayer,
The Winnipeg Art Gallery - p.14.
Typesetting: Contemporary
Typographers Limited, Edmonton.
Colour Separations: RN Graphics
Limited, Edmonton.
Printing: Reliable Printing
Limited, Edmonton.

Cover:
Victoria Mamnguqsualuk
untitled, 1973
graphite and coloured pencil on paper
56.7 x 76.6 cm

Contents

Foreword

This exhibition, sponsored jointly by the Boreal Institute for Northern Studies and Ring House Gallery of the University of Alberta, opens concurrently with the conference "Knowing the North: Integrating Tradition, Technology and Science", hosted by the Boreal Institute, November 20, 21 and 22, 1986.

For their indispensable aid in preparing both the exhibition and its catalogue, I am indebted to all the staff of Ring House Gallery, but in particular to Marian Butler, Bernd Hildebrandt, Jim Corrigan, Margaret Carmichael, Rob Kassian, and Helen Collinson, Curator of the Ring House Gallery. A.S.A. Mohsen, Director, Boreal Institute, and James Parker, Director, University Archives and Collections, lent their generous support to the project. Nancy Gibson, Neeta Cooke, Anita Moore and Bernice Jones of the Boreal Institue provided valuable help in the preparation of the catalogue. Research for the catalogue was undertaken thanks to a timely grant from the Office of the Vice-President (Research), University of Alberta.

Jack Butler not only contributed his essay to the catalogue, but also gave much needed advice and assistance that helped to bring it to completion. Welcome information about the work of Victoria Mamnguqsualuk was received from Ingo Hessel of the Inuit Art Section, Indian and Northern Affairs Canada; Odette Leroux, Curator of Inuit Art, Canadian Ethnology Service, National Museum of Man; Marie Routledge, Assistant Curator, Canadian Art, National Gallery; Judith Nasby, Director, Macdonald Stewart Art Centre; and Sandy Cooke, The McMichael Canadian Collection. Drawings by Mamnguqsualuk in the collections of the Macdonald Stewart Art Centre and the McMichael Canadian Collection were especially valuable in our forming a broader understanding of this artist's work with myths and legends; and in our text these drawings are referred to by the name of Bernadette Driscoll, Associate Curator of Inuit Art, Winnipeg Art Gallery, in whose excellent exhibition catalogue, *Inuit Myths, Legends and Songs*, they are reproduced. Bernadette Driscoll and Darlene Wight, Winnipeg Art Gallery, facilitated our viewing of the videotaped interview with Mamnguqsualuk produced by the Inuit Broadcasting Corporation (1982) in conjunction with that exhibition.

The "Keeveeok" prints of the exhibition (not reproduced in the catalogue) were graciously loaned by the Edmonton Art Gallery from its collection of the first edition of Baker Lake Prints, 1970, and by a private collector from Edmonton. Most importantly, Victoria Mamnguqsualuk of Baker Lake gave us her kind permission to reproduce in this catalogue her twenty drawings in the University of Alberta Collections. For their good offices, we are also grateful to Pamela Brooks and Grace Eiko Thomson, respectively Manager and Art Advisor of the Sanavik Co-operative Association, Baker Lake.

The spelling of Mamnguqsualuk's name used in the catalogue is that approved in 1972 (prior to then, one finds her name written as Mammookshoarluk, Mummokshoarluk, Mumngshoaluk, and Mumngushowaluk). Similarly, the great legend hero's name has been spelled variously in English: Keeveeok, Kiveoq, Kivioq, Qiviuq, etc. In his essay Jack Butler uses the now generally accepted spelling, "Qiviuq", while for the exhibition's title and my essay I have adopted "Keeveeok" since the print "Keeveeok, Awake!", from which the exhibition takes its title, had this spelling; and I also hope that this spelling will appear more straightforward to the general public. However, the reader of the catalogue will find that, in the versions of this legend recorded in different areas of the Canadian Arctic, the spelling of the legendary hero's name has as many forms as he has lives.

Identification of the myths and legends was facilitated by the text in Inuktitut, accompanied by Jack Butler's English translation, that appears on the back of a number of Mamnguqsualuk's drawings. As the drawings and their texts relate to single episodes or to a series of episodes in the myths and legends, a fuller discussion of the complete stories is given in the text of the catalogue. Here, in brackets, one will find reference to some of the many variations of these old stories as told formerly, with emphasis on the traditional versions of the Utkuhikhalingmiut, their closely related Netsilingmiut neighbours to the east, and their Copper Eskimo neighbours to the west. Although these "--miut" designations of Inuit groups are not used by Inuit in referring to themselves, they serve to identify the oral traditions of different regions and, thereby, help us to compare variations of the old stories and to appreciate more fully the particular versions that inspired Mamnguqsualuk. Whether reading the catalogue's text or the résumés of myths and legends on the wall-panels of the exhibition, one must bear in mind that these stories were meant to be told, not read, that English translation has lost the flavour of the spoken language, that translation cannot even convey all the exact shades of meaning, and that a plot summary is merely a physical skeleton of the living legend.

Finally, for its financial support in making this catalogue possible, we are very grateful for a Special Presidential Grant from S.S.H.R.C. (Social Sciences and Humanities Research Council) and, for the means to mount the exhibition itself, to the Emil Skarin Fund.

C. H. Moore
University of Alberta

4

Victoria Mamnguqsualuk, Baker Lake,
July 1969, photograph by K.J. Butler

Victoria Mamnguqsualuk

Mamnguqsualuk was born in 1930, on the land, near Garry Lake in the Northwest Territories. Her mother, Jessie Oonark, was to become one of the foremost, contemporary Canadian graphic artists. Raised by her grandparents (grandmothers were traditionally storytellers in Inuit society), Mamnguqsualuk would later interpret graphically some of the old stories told to her as a child. She was already an adult when she returned to her parents' family. Married to Samson Kayuryuk, whom she had known since childhood, she gave birth over the years to nine children, of whom five are living.

It was partly because of her children's education that Mamnguqsualuk and her family, like many Inuit from groups throughout the Keewatin district after the dreadful years of hunger and illness, moved into the Baker Lake settlement, in 1963. Here, she became active in the embryonic art program, at first doing stone sculpture, which she found to be very "strenuous." She then turned to drawing and the making of wallhangings — artistic areas more closely related to the traditional work and skills of Inuit women in the design and cutting of hides and furs for family garments. Encouraged by Jack Butler, who had come to Baker Lake as craft officer in 1969, to make drawings of the old stories, Mamnguqsualuk had eight of her drawings chosen for the first edition of Baker Lake prints in 1970; three of them depicted episodes of the Keeveeok legend. Over the past twenty-five years, prints made from drawings by Mamnguqsualuk have appeared in each of the annual Baker Lake print collections, except 1974-76. She has also created many large wallhangings that depict the old stories or combine the motifs of several legends. Today, Mamnguqsualuk is one of the most prominent of Baker Lake artists.

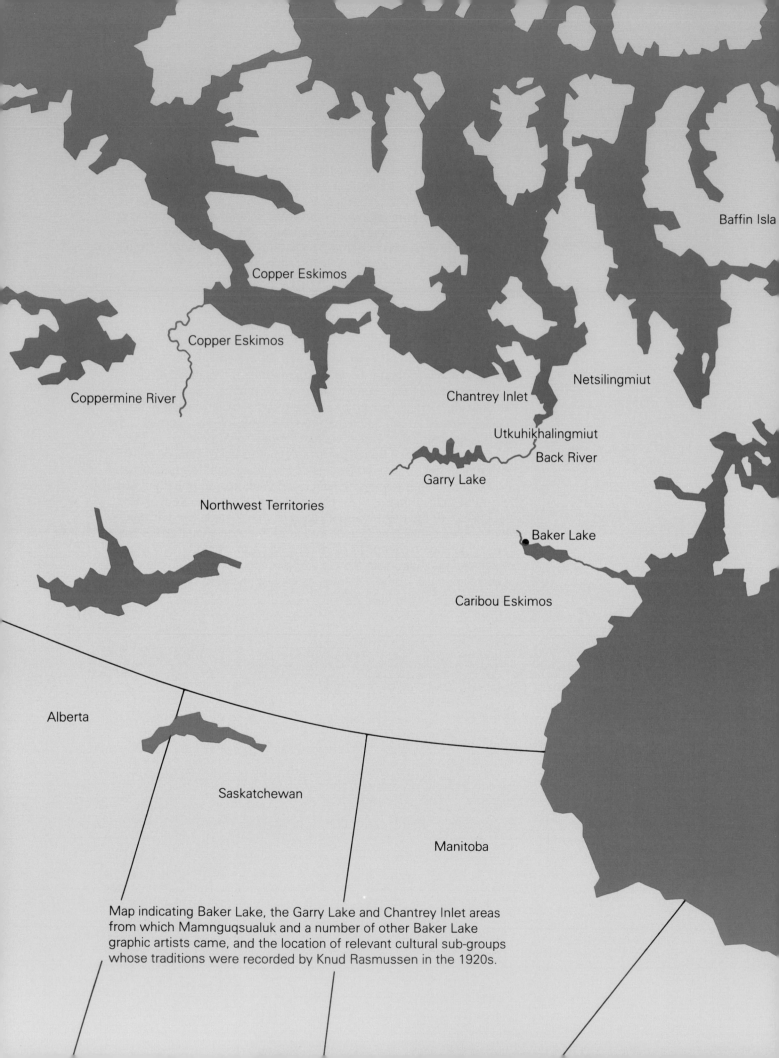

Baffin Isla

Copper Eskimos

Copper Eskimos

Coppermine River

Netsilingmiut

Chantrey Inlet

Utkuhikhalingmiut

Back River

Garry Lake

Northwest Territories

Baker Lake

Caribou Eskimos

Alberta

Saskatchewan

Manitoba

Map indicating Baker Lake, the Garry Lake and Chantrey Inlet areas
from which Mamnguqsualuk and a number of other Baker Lake
graphic artists came, and the location of relevant cultural sub-groups
whose traditions were recorded by Knud Rasmussen in the 1920s.

Keeveeok, Awake!
Mamnguqsualuk and the Rebirth of Legend at Baker Lake

The making of drawings and prints based on Inuit oral tradition has been especially strong in the case of a few contemporary artists from the communities of Holman, Povungnituk and Baker Lake — in other words, from all areas of the Canadian Arctic. That activity is not essentially different from the visual representation, by Inuit artists in general, of their traditional way of life, known first-hand only to the oldest among them and to others mainly from the stories of their elders. Legend drawings are then, like stone carvings, prints and wallhangings, part of that broad, creative expression of a cultural heritage that has been, for more than thirty years, one of the most remarkable phenomena of Canadian art. In this context, however, the visual representation of myths, legends, and folklore has special significance, for many of the old, revived stories have roots that extend not just into the pre-settlement period of Baker Lake, but into the long-forgotten past of the whole Inuit people, before white men set foot in the New World; and the very passage from oral literature to drawn or printed image has taken place in an extraordinarily condensed period of time.

Transmitted from Alaska to Greenland and passed on orally from generation to generation, Inuit myths and legends were recorded and published in modern European languages primarily during the late nineteenth and early twentieth centuries by ethnologists such as Henrik Rink, Franz Boas, Diamond Jenness and Knud Rasmussen. For the semi-nomadic Inuit, however, the tradition remained oral. Although they made images related to their oral tradition with sharp objects on bone, ivory and natural surfaces (McGrath, 1984:16-18; and see plate 3) and although they occasionally made drawings at the request of white visitors, pencil, paper and print were not yet part of their own material culture. Finally, during the 1950s and 1960s, when the dire need for food, health care and education drove Inuit from all over the Keewatin into the Baker Lake settlement, they brought with them memories of a way of life almost extinct and the remnants of its values, beliefs and oral tradition. Under the rapidly increasing pressures of acculturation, the old stories now began to make their way into the relatively recent written language of the Inuit and, more dramatically, from the oral language into drawings and printed images made by the Inuit with materials and techniques from Southern Canada.

The "spoken" quality of the oral tradition carried over strongly into the printed words and images (McGrath, 1984:14-21).Nonetheless, to appreciate this leap, we should recall that it took centuries for Western oral literatures to reach expression in the written language and centuries more before the printing press revolution facilitated their public dissemination. Moreover, since late medieval times, the relationship of Western literature and art, especially in the area of drawings and prints, has been very close. In the case of the Inuit oral tradition, its passage into the printed language and image, compressed into a few decades, attests to a "McLuhanesque" revolution in which technology and modern media threaten to "submerge" a traditional culture and, paradoxically, awaken efforts to perserve it. In a larger sense, this particular history is that of all Inuit culture.

In one episode of the Keeveeok legend, the dead call to him, "Keeveeok, Awake!"; and, in some versions of the legend, an epilogue has it that the immortal, indomitable Keeveeok disappeared into the world of the white man, but that, before the end of the last of his many lives, he would surely return to the Arctic. From Baker Lake he has once again answered the call to life and announced his return. Already, in educational comic books, we are told, he has hurled his harpoon to knock out of the sky a Soviet satellite that risked falling on Baker Lake (McGrath, 1984: 71). It is possible that, one day soon, his people will again hear his story told, as they watch his image, on the TV screens of the Inuit Broadcasting Corporation.

* * *

The non-Inuit is bewildered by the casual way in which real and imaginary mingle in the old stories. How did the Inuit interpret the ubiquitous supernatural, the dominant feature of their legends?

> A person could become an animal, and an animal could become a human being. There were wolves, bears, and foxes but as soon as they turned into humans they were all the same. They may have had different habits, but all spoke the same tongue, lived in the same kind of house, and spoke and hunted in the same way. That was the time when magic words were made. A word spoken by chance would suddenly become powerful, and what people wanted to happen could happen, and nobody could explain how it was. (Rasmussen, 1931: 208)

 What we call the "imaginary" in literature — the supernatural, fantastic, magical, marvellous; apparition, vision, dream, hallucination; grotesque combinations of human and non-human — was simply not seen as "imagined" by the ancestors of today's Inuit; and even now, some Inuit continue to believe in the spirit creatures of old (Zepp, 1986:22). Whereas in the Western European literary tradition we enter the realm of the imaginary with advance notice of a different reality through changes in lighting and space, in the mind of the Inuit men and spirits shared the same natural environment. Whereas in our literature we are ever conscious of the incompatibility of everyday reality and the supernatural that intrudes on it, there was no doubt or contradiction in the mind of the Inuit. For them, the imaginary in its various forms was neither fiction, nor literary device, nor artistic licence. It was fact: long ago people and animals *were* able to converse and change form, no doubt about it! It was belief — belief in the indivisible relationship of man and the animals on which survival depended completely and absolutely; belief, too, in the people's ability to survive, regardless of nature's unpredictability, through experience, resourcefulness, and especially, respect for the spiritual life that animated everything real. In their continuous and bitter struggle for food and clothing in an unforgiving environment, the Inuit created their myths and legends as part of this belief system; and the formalization itself of belief, in myths and legends, helped them to accept, endure, and preserve their precarious way of life. The myths and legends had, then, besides their social function of uniting people through a common pool of beliefs, a historical and religious significance: as Rasmussen observed (1931: 207), "all that is described in them really did happen once, when everything in the

world was different to what it is now" and "in many respects their religion is entirely based upon the tales." What we call the "imaginary" was for the Inuit a still living part of the original experience of their people, their history and religion.

The reality of the "imaginary" and the function of legend was maintained even into the twentieth century. "It is said that it is so, and therefore it is", affirmed one of Rasmussen's informants (1931: 207). And Rasmussen (1931: 522-23) says of the legendary hero Keeveeok that, among the Utkuhikhalingmiut "as among the Caribou Eskimos, I was asked whether I had not met him on my journeys. It is true that he is looked upon as a legendary figure, nevertheless as a live man, too, one who has existed through many lives and many generations.... He is said to be on his last life now". However, under the assault of Western technology, the traditional belief system and the hold of legends were already weakening.

In his autobiography, Nuligak (1966: 67) related the decline of storytelling to the arrival of the phonograph. More generally, it had already begun — as an old hunter of the Utkuhikhalingmiut told Rasmussen (1931: 500) — when the Inuit acquired rifles in trade with white men: if seal and caribou could be had from afar, the spiritual powers of amulets, magic words and shamanic intercession were no longer as essential; and, with a decline of belief in the supernatural, the myths and legends of old began to lose their most vital appeal. The new religion of the Christian missionaries was also to contribute, in some regions, to a shunning of traditions. Generally, intercourse with white men and their technology were destroying interest in the old stories and their telling (Rasmussen, 1929: 251). While Rasmussen made this observation about the Iglulik Eskimos, Jenness (1924:1) could say the same about the Copper Eskimos, some 1400 kilometres to the west:"...there appears to be little interest in the old traditions." The statement "He [Keeveeok] is said to be on his last life now" was, in fact, an acute observation of cultural change. Still, one could not have guessed that, some fifty years later, we white men would meet him at last through the drawings and prints of a contemporary Inuit artist.

* * *

The myths and legends transformed visually by Mamnguqsualuk were likely versions told by the Utkuhikhalingmiut from the Chantrey Inlet and upper Back River area (some 200 miles north and northwest of Baker Lake) and by neighbouring groups to the east and west, for her family came from this area, the oldest of the Baker Lake storytellers lived most of their lives here, and a close relationship existed between the intellectual cultures of all these groups. In fact, across the whole Arctic, Inuit tribes told essentially the same myths and legends. "It is astonishing", wrote Rasmussen (1931: 363), "how identically the subject and substance of the tales is constructed and remembered by all." Moreover, within this broad body of oral literature one finds a large number of common themes and motifs: the abused child, typically an orphan, who gains supernatural strength and avenges himself; wives who have the resourcefulness to make

out on their own when, for one reason or another (commonly mistreatment), their marriage breaks up; the bachelor, scorned by women, who takes an animal or bird to wife (and does just fine); the woman who rejects all suitors and, as punishment, gets an animal or bird as spouse (and has a bad time of it); children who are raised by animals, and animals raised by humans; the Inuk who encounters malevolent spirits and knows how to outwit them; and so on.

Nonetheless, despite their basic similarities, myths and legends varied considerably from region to region, both in detail and in form. Jenness (1924:1) noted, for example, that Alaskan Eskimo stories still had "a definite beginning and ending", while those of the Copper Eskimos seemed to be "disjointed fragments". Legends told as autonomous stories in some regions were, in others, amalgamated in larger stories or cycles of legends involving the same principal figures or single hero. "An Eskimo traditional tale can be told in total or part" (McNeill, 1967: 59). Such is true of the Keeveeok legend, composed of numerous episodes, of which several were traditionally told — in some, not all, regions — as independent legends, often with a nameless man as hero. Had these separate legends, over time, broken off from their original matrix, or had the most basic myths and legends, with their powerful protaganists, assimilated these other stories as episodes within their larger structure? The lack of answers to such questions, the degenerative nature of many contemporary Inuit narrations taken as examples, and the temptation to judge the traditional stories using criteria applicable to our own written literature have led to some questionable observations about the internal working of Inuit myths and legends. Carpenter (1971: 17), discussing an unnamed "poetic tale" told to him (and which sounds very much like the Keeveeok legend), characterized it as a series of self-contained, interchangeable episodes "in random order", lacking plot structure and suspense; and Lochhead (1978: 151) found the stories to be "a cluster of experiences that can be arranged at will…at no point does one part necessarily lead to the other." These impressions are undoubtedly valid for many contemporary versions of the old legends. Moreover, such a complete lack of structure, order, plot development and suspense would certainly help to explain why episodes could often be told as separate legends and, just as frequently, incorporated freely in larger narrative structures. However, in the case of the corporate Keeveeok story and of some other myths and legends, we find older versions from various regions in which episode sequences are so markedly similar that one cannot dismiss the idea of structure and fixed order in the original legends.

Consider, for example, the following sequence of episodes: blind boy shoots intruding bear; (grand)mother lies to him, keeps meat, and starves him, but sister slips food to brother — boy's sight magically restored by loons — boy and sister take revenge by drowning (grand)mother (attaching their harpoon-line to her so that their prey pulls her under the sea) or otherwise killing her — remorsefully, brother and sister set off wandering and must face dangerous spirit creatures from which brother saves wounded sister — sister marries and gives birth; to do likewise, the "bottomless"

women "puncture" themselves — in darkened igloo, man makes sexual advances to sister; discovering man to be brother, sister severs her own breast, hurls it at him and flees; sister escapes to the sky as the sun, pursued eternally by brother-moon, but forever separated from him. These episodes could be and, in fact, were told in some areas as separate legends; but their amalgamation in a fixed order also created a wholly coherent narrative, apparently governed by a basic belief in the inevitability of redress and retribution and in the wrongfulness of incest. The myth is characterized as well by a strong degree of internal unity: the symbolical pattern of the initial episode (inability to see, deception, and revelation of truth) is echoed in the closing episode; and in those episodes where the sister is the centre of interest, the motifs of wounds, self-mutilation and blood appear to be deliberately repeated. Moreover, the fairly fixed order of events in such composite stories, known to all, perhaps substituted for the interest of suspense the more usual excitement of traditional storytelling — anticipation.

The reasons for differences in versions of the legends from one Arctic area to another are now nebulous, lost in the distant history of their transmission and of the various tribes. One can, however, glimpse the causes of certain variations. When an episode was related as a separate legend rather than as just one narrative unit of a larger story, the episode's ending was subject to alteration, commonly in the form of a strong conclusion. The legend that appears comprehensive in one region may have only a sketchy version in another; and this shorter version may simply reflect the informant's lack of knowledge, faulty memory, or abridgement of the story on the assumption that everyone knows all the parts omitted — an occurrence noted frequently by Rasmussen. Variants commonly relate also to the particular economy of a region: the parts of a legend referring to a coastal, sea-mammal economy were often changed or dropped in the versions of inland people whose lives depended on the caribou. Similarly, legend versions from different areas were marked by their particular geography: the mountain created by Keeveeok was said to be a ridge of land in Adelaide Peninsula; his river, the "New River" (likely a Back River tributary), or the Coppermine River; Keeveeok himself was said to have lived "not far from Ilivileq", or "on the island of Aivartoq"; his adventures began "at Sentry Island just off Eskimo Point"; the island to which "the girl who married a dog" was banished was "in Ugjulik, not far from Sherman Inlet"; and so on. The rooting of a legend in the geography of ones area, this localizing of the legend, may well be, along with belief, one of the key factors in the stability of a regional version.

Although, over many years, changes may have come into regional versions of legends through the intercourse of different tribes at great meeting places such as the one called "Akilineq" in the Keewatin (Rasmussen, 1930, III: 153-154), those changes were likely slight once the local version had been well established. As Spencer noted (1959: 384): "No one tired of hearing the same tale recounted. Indeed, it was in this way that the stories took their

verbatim character." In recent times, the situation has undoubtedly changed. Nungak and Arima (1969: vi), for example, received different versions of the same legend not just from several informants, but from the same individual. Indeed, some discrepancies occur in the various texts accompanying Mamnguqsualuk's drawings and prints of legends and in a videotaped interview in which she relates the legends of her drawings. Even more extensive change, but of a completely different order, takes place when visual imagery replaces the spoken word of the old legends.

<p style="text-align:center">* * *</p>

Although her graphic work includes highly imaginative, personal interpretations of folkloric subjects, Mamnguqsualuk's approach to the legends in the drawings of this exhibition appears at first glance to be strictly literal and narrative. The drawings "read" in a way not unlike that of comic-strips: characters are seen in a succession of acts. However, unlike our comic-strips, there are no formal divisions, no blocks or frames isolating events, time or place. Nor do her images of events unfold from left to right along a single groundline, although they are usually oriented to the bottom edge of the paper. In a circular movement, clockwise or counter-clockwise, or stacked vertically on one side, then on the other, the images develop pictorially in relation to the paper's four sides; or they follow one another in a zigzag manner: horizontally across the top, then diagonally, then horizontally below. Exploiting fully the overall surface (as in her wallhangings), her composition is more varied than what our bookish eyes are used to in narrative art. Within the rectangle, our familiar, illusionistic space is replaced by a flatter, but more open time-space relationship, as if the paper were the land itself, sometimes like a chart of Keeveeok's endless wanderings, as if the scope and timelessness of his exploits could not fit into our single, limited perspective and unitary time.

Since the drawings exist not merely as "illustrations" of myths and legends but have an aesthetic life of their own, the oral source material undergoes substantial change when made visual and temporal, when fixed to a flat, rectangular surface. Still, the outlined, strongly two-dimensional, look-alike personnages of the drawings are scarcely less human than their oral counterparts of the legends, for the latter are rarely individualized physically: legend commonly tells us just of "this man" or "this old woman"; and character is revealed not by analysis but by externalization, by "labels" such as "kind" or "evil", or by acts and deeds.

However, in the drawings, gone are the storyteller's personality, expressions, gestures and interplay with audience, all of which contributed to the enlivenment of characters. Gone, too, the earthy dialogue of the oral legends — stories once both diversified and unified by voice rely now completely on line and composition. Consequently, the world of legend drawings seems unnaturally silent; and, in that silence, fear is frozen in a gesture, cruelty riveted to the instant of an act.

Despite the openness of time and space in the drawings, the free flow of the oral process cannot find an equivalent visual continuum. The very physical limitations of paper break down the legend, even the episode of a legend, into a restricted number of visual, narrative elements, which Mamnguqsualuk must edit in her head, selecting the successive scenes and actions that she will set to drawing. It may appear on paper that these narrative elements, flowing freely, lack temporal and causal connectives; but in the original oral legends, too, time is uncertain; and cause and effect need not be logical in a world where words themselves can have magic power.

Perhaps a more serious consequence of the passage of a legend from the oral to the visual is the loss of setting, of milieu, such as we find in numerous versions of oral legends where the story has been rooted, localized, in the geography of a particular area. On the other hand, the drawings obtain a generalized, physical reality that spoken words cannot create except in passing.

Are we to conclude that the changes which the oral legends undergo when made visual represent a diminishment? In the deepest sense, that would appear to be so, for "the language carries all reality for Eskimos" (Williamson, 1965: 8). However, through a re-experiencing of the legends, the graphic artist discovers that the verbal shapes of thoughts are not a final reality. Keeveeok's "bird-wife" and "bird children", for example, can be seen in bird form, or human form, or with human bodies and bird heads, or bird bodies and human heads. In her works, Mamnguqsualuk sees them in all these ways. She shows us that an "empty Indian camp", from which the adults are all out hunting, can be imagined as a long row of children hung up in their carrying cradles. Storytelling and the suggestive power of words allow the image-maker of legends to imagine, to create. Rasmussen concluded (1931: 267): "In all the old legends the marvellous, the incredible, the supernatural plays an extremely important part, in fact it is the pivot of intrigue and action." It is in her creating image forms for all that is "imaginary" that Mamnguqsualuk's art enriches the old stories of her people.

C.H. Moore
University of Alberta

14

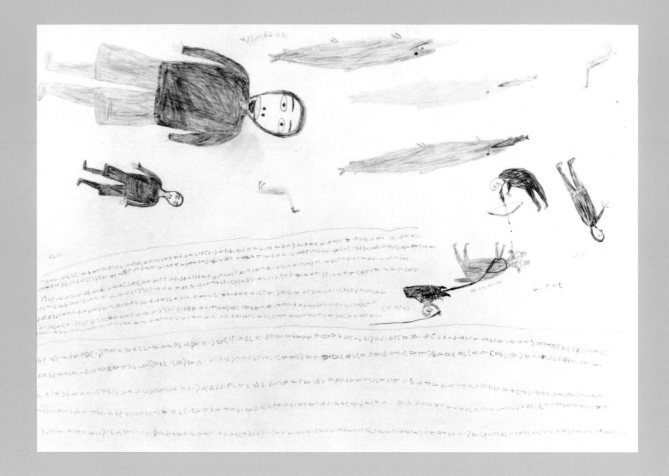

Luke Anguhadluq
Kiviuq, 1970
graphite on paper
71.1 x 101.6 cm

Photograph by Ernest Mayer,
The Winnipeg Art Gallery.

In 1922-23, Ikinilik, an Utkuhikhalingmiut Inuk, was speaking to the Danish explorer Rasmussen.

> Now that we have firearms it is almost as if we no longer need shamans, or taboo, for now it is not so difficult to procure food as in the old days. Then we had to laboriously hunt the caribou at the sacred crossing places, and there the only thing that helped was strictly observed taboo in combination with magic words and amulets. Now we can shoot caribou everywhere with our guns, and the result is that we have lived ourselves out of the old customs. We forget our magic words, and we scarcely use any amulets now. The young people don't. See, my chest is bare; I haven't got all the bones and grave-goods that the Netsilingmiut hang about them. We forget what we no longer have use for. Even the ancient spirit songs that the great shamans sing together with all the men and women of the village we forget, all the old invocations for bringing Nuliajuk up to earth so that the beasts can be wrested from her — we remember them no more. (1)

1. Knud Rasmussen, *The Netsilik Eskimos.* Report of the Fifth Thule Expedition 1921-24, Vol. VIII, nos. 1 and 2, Copenhagen, 1931: 500.

The coming of new ways always means the passing of the old. It was so centuries ago in the west, and it is happening even now among the remaining old cultures of the world. And yet, not all the old memories are always lost.

An Inuk riding a two-headed dog — an igloo containing ten severed heads — an Inuit woman holding an ulu to her face, about to slice off her eyelid — and most often a tiny man riding on the back of a giant fish. These images appeared again and again in sketchbooks made by the Inuit in Baker Lake during the summer of 1969, but it was some time before we understood their meaning.

My wife, Sheila, and I had gone to Baker Lake to introduce printmaking techniques to the Inuit of the central Barren Grounds. Most of these traditionally nomadic hunters had been brought into the settlement during the late 1950's and early 60's. The Federal Government had opened an arts and crafts centre to encourage the making of soapstone sculpture, an effort to provide employment for these displaced people who were at the time living principally on welfare. A succession of white crafts officers had come and gone. Some significant sculptures had been produced and some very good sculptors were developing. Under the direction of some of the crafts officers, printmaking had been unsuccessfully attempted. So our invitation to the Inuit people to try printmaking again was greeted with hostility.

We found several sketchbooks of line drawings in the Craft Shop. It was evident that many of the drawings were made by novices holding a pencil for the first time. But they were images of power and promise. Experience with drawing was all that would be required to develop these new draftsmen into confident artists.

As strangers in the settlement, unable to speak Inuktitut, and working in a crafts program tainted by former conflicts between government and Inuit, we found it very difficult to meet the potential artists whom we had come to the Arctic to develop. So we adopted an indirect approach, seeking to draw them towards us. We offered to purchase sketchbooks of drawings, any kind of drawings, without regard to quality, and from anyone who would try to draw. The drawings were purchased with funds provided for this purpose by the Federal Government. At first it was mainly children who returned with drawings, some beautiful work, direct and fresh, full of caribou and skidoos. Among the children's work we found an occasional

page obviously drawn by a more mature hand. These were often tentative, hesitant drawings, drawn with shaky pencil lines but demonstrating a clarity of image and conception. We would remove these drawings from the sketchbooks, pay for them separately, and send the children home with a book especially for the parent. We encouraged the Eskimos to draw more often, on a larger scale, and to value their drawings as valid statements about their own culture.

From the very begining of our project, the drawings covered a wide range of subjects. It was impossible for us to know if a particular image was a personal fantasy or an illustration of a classic legend. It seemed, however, that the very process of drawing was encouraging a renewal of interest in some frequently repeated visual themes that we felt must be associated with traditional legends.

Subject matter was not a prime issue when it came to selecting drawings for use by the printmakers. When a drawing was selected to be made into a print, the choice was based on the aesthetic merits of the image and the conduciveness of the drawing to translation by the printmaking process of stone cutting and stencil cutting. The delicate, intimate and unique pencil drawing would be transformed into a public statement in an edition of fifty prints. Lines would have to be made bolder, colours simplified. The subject matter of the print would have to be made understandable to a wide audience. This created some interesting problems when the subject matter was incomprehensible or when there was syllabic script included in the image. The print by Mamnguqsualuk called *Confrontation,* from the 1970 collection, was just such an intriguing image and text. The text on the print read, "You must kill the leader of the people with the fleshless legs" (Nakasungnaicut). There are two drawings in this catalogue related to the same theme, and their cryptic texts give a good example of the kind of mystery we were facing: (Plates 13 and 14).

It became evident to us that these were fragments of a legend. However, during that first summer in Baker Lake, none of the young Inuit translators or printmakers who spoke English knew this legend. And none of the older artists were willing to explain it to our translators.

It was our custom that all aesthetic and policy decisions should be made by the whole group, including ourselves and all the Inuit involved in the project. We had long discussions about which drawings to use for prints, and how to translate syllabic texts. It was decided by the group that we should go to Luke Anguhadluq, the eldest hunter of the Back River group, and an artist, with a request that he make a drawing and tell the story, the whole story, of which these fragments were a part.

Anguhadluq made a huge drawing that pulled these fragments together and he wrote the story in syllabics on the face of the drawing — an illustrated text. Unfortunately he had had very little experience with writing and his syllabics, lacking the "finals" of modern syllabic script, were too generalized to tell the tale with the richness of detail that he intended. So we put together a team of

Inuit who discussed the legend and questioned Anguhadluq and
finally, under the direction of Ruby Angrna'naaq, an amplified
translation was written down in limited English. The final step in the
translation process was left to me. I have re-written the legend in
readable English, staying as close to the spirit of the legend
as I was able.

A long, long time ago there was a man who walked alone.

He sighted an igloo and walked toward it, but it was empty. He walked on
into another area and saw many little igloos. Just before he got to the first little
igloo, where he planned to enter, he saw a very large igloo further on. He went
inside the big igloo, There was a woman who dwelt in it. She was sewing. She
became aware that someone had entered her igloo and she said to the Man,

"Now that you have come to our land, how do you plan to escape being
murdered?"

The Man answered, "Oh, I am so afraid of being killed!"

Then he said that he wanted to depart from that place before being discovered
by the rest of the Inuit there.

The woman said, "Even if you depart they will track you by your footprints,
follow you and kill you."

The man asked, "Is there a place for me to hide?"

"Get up there where we keep our clothes, in the corner of the igloo. And
take off your kamiks [skin boots]."

While he was hiding, two children came into the igloo and said, "I smell a
grown-up man."

The woman said, "How do you know there is a man around?"

The next two kids ran out shouting and yelling, "The next-door woman's igloo
smells of a man."

There was silence for a while, then, outside she heard someone's footsteps.

A woman entered and said, "I smell the smell of a man."

The woman who was sewing became angry.

"There is no man here. What makes you think that there is?"

At this the visitor became suspicious and started looking around. She saw the
kamiks turned inside out to dry.

"In that case, whose kamiks are these?"

"Those are my husband's kamiks."

"And why have they such unusual lining in their soles?"

"I make all kinds of sole linings. They just happen to be like that."

The visitor left shouting, "The next door woman's igloo smells of man."

The dawn came before she heard footsteps again. This time it was her
husband and two children and they said the same thing as all the others had
said. Then the woman who hid the man admitted,

"There is a man who asked me to hide him. And I did."

Her husband called out, "If there is a man hiding, would you please come out
of your hiding place."

The Man was afraid but came out. He was fortunate because this husband and
wife were not cannibals. They were willing to help him.

Then the woman's husband warned him. "The leader will be coming in here
followed by the rest of the people.

When he starts to enter the igloo I will ask him to close his eyes and he will
obey me. I want you to throw a rock at his eardrum with all your might."

Then they heard the people coming. The husband said to their leader, "If you
do as I ask, I will give you nice fat seal meat. Now do this. Close your eyes and
shake your head left and right."

The leader did as he was told. The Man then threw a rock at the leader's ear
and killed him. The leader's gang pulled him out of the igloo backwards and
proceeded to chop him up starting right between his ribs.

The leader's two kids came running in licking their hands and saying, "Oh! My
father has lots of fat on his kidneys."

The woman said, "So that is your father?"

Those people brought in half of the man's buttocks and added it to the pot of cooking seal meat.

Once it was cooked, they asked the Man, "Do you eat seal or man's flesh?"

"I don't eat the flesh of a man but I do eat seal."

When they finished eating, they told him what he must do to escape.

"When these people sleep, they sleep deeply. Once they are asleep, find their kamotiks [sleds] and cut every single sinew that binds them together. Do not miss even one sinew. If you fail to cut even one little sinew they will track you down. The leader's dog has two heads and they will use him to track you. The dog will wag his tail and howl before he jumps on you. Shoot him with your bow and arrow right in his ear, just as you did their leader."

So when the people had gone to sleep, he did as he had been told. He cut the kamotik's sinew, down to the last little bit of sinew. He escaped from the group of igloos in the middle of the night. When the sun was rising up, he heard a whip lashing and the moan of a dog. The dog's cry sounded as if there were two dogs.

He thought to himself, "So I must have missed cutting one little sinew out of all those sleds. The dog is following me."

Once he saw them, they were coming at him fast. The man who was following was wrapped in skins. His dog had two heads. The dog started howling and was ready to jump. The Man readied his bow and shot just as the dog jumped. He shot well, right into the dog's ear. The dog moaned and started to run away. His master shouted to him, "Alulla'q, Alulla'q", but the dog splashed into the water and both Alulla'q and his master were drowned.

The man in this story was Qiviuq. We had met him briefly and unknowingly before, fleeing from a two-headed dog or riding on the back of a giant fish; but this was our real introduction to this great hero of Inuit legend. Ulysses-like, Qiviuq travelled long and far, encountering many strange people and fantastic creatures and braving many perils on his journeys.

Thanks to Anguhadluq's rendering of the Qiviuq legend it became apparent that, in addition to the print titled *Qiviuq's Journey*, there were two other prints in the 1970 collection that were about the legend: *Confrontation*, described above, and *Riding Dogs*, which depicted Allulla'q, the two-headed dog. All of these prints were made from drawings by Victoria Mamnguqsualuk. Following Anguhadluq's example, she and several other artists, such as Janet Kigusiuq, Ruth Annaqtuusi and Myra Kukiiyaut began to make more and more drawings, based on oral legends. Little by little, during the first two years of our work in Baker Lake, the legend fragments associated with each individual's drawings came together to form whole episodes of recognisable stories. The artists represented a wide variety of originally diverse Inuit groups and they enjoyed making comparisons between each family's versions of classic legends. Anguhadluq was often consulted as an authority on the Back River versions of the legends. His localised rendering of the great origin myth of Nuliayuk, (Takannakapsaaluk) is a good example. In the most frequently related versions of the myth, Nuliayuk is a woman who refuses to take a husband. Through misadventure her father cuts her fingers off at the first knuckle and the tips become small seals; at the second joint, the fingers become bearded seals and at the third joint they become walruses. In Anguhadluq's version, the land-locked people of the Barrens, who have little contact with sea mammals, have a different fate in store for the heroine.

There was, a long time ago, a kayaker who came upon a woman, a woman who would not marry. When this man came to her by kayak he asked her to kneel down on his kayak for him. But this woman did not want to do as she was bidden so she stabbed him with a knife, took off his wooden sun goggles and looked into his eyes and said, "Who would want to marry a man like you?"

She started climbing up the hill. As she was climbing her hands began to turn into stone. Now her hands had become stone. To see if her hands had become stone she clapped them together. Sure enough, they were sounding like stones. Now she had turned completely to stone and now she sits upon the ground beside the Back River. When there are a lot of fish to climb the River this stone looks beautiful. When there are not to be so many fish the stone does not look so beautiful.

The colour of this woman of stone is clear rock white.

In 1972 the Government Arts and Crafts program was turned over to the newly formed Sanavik Co-op with Ruby Angrna'naaq as the first printshop manager. An excerpt from her introduction to the 1973 print catalogue conveys the general feeling at that time.

To work in a printshop like the one here one must be able to mix work with pleasure, things like watching two men handwrestling (Urqsaraaq), hearing old Scottie's tales of yester-years, someone playing with an Eskimo drum, or the pounding of someone making a skidoo and more. One must also be ready to face criticisms on his work, especially at the Monday afternoon meetings. One must have a good reason for printing in a certain colour, or for not taking the garbage out the night before, or even a good explanation for why you wore a certain shirt all the time. (2)

2. Ruby Angrna'naaq, *Baker Lake 1973 Prints*. Sanavik Co-operative, Baker Lake, N.W.T. 1973, N.P.

In 1973 Mamnguqsualuk produced about sixty drawings with texts for the Sanavik Co-op. Most of the drawings in this catalogue are from that group, and several depict other episodes in the Qiviuq saga as well as other legends. For instance, Plates 17 and 18 illustrate the classic myth of the origin of the white races which she first illustrated in her 1972 print *Legend*. She has continued to make drawings dealing with the old myths to the present day, and she often returns to the same story over and over again. She commented during one interview, "I heard this story as a child but I don't know the ending because I always fell asleep." So, as friends and relatives contributed to her recall of the legend, she made a new drawing with more text. A team of translators worked in constant consultation with Mamnguqsualuk, and the translation sessions were hilariously funny. As you can see from the drawings many of the stories are very earthy.

The legends were not the only aspect of Baker Lake drawings which require translation. Communication in visual art is accomplished by the effective marriage of content and form, and both must be understood in order to appreciate the work fully. In this case, both these elements reflect the contemporary Inuit experience as Ronald Bloore has perceptively described:

Contemporary Inuit art is a revelation of cultural identity in the process of transformation.

In the difficult activity of image-making memories of ancestral traditions are retained and carefully selected factors from the gradually shifting present are slowly introduced. Upon reflection some of it seems to be a sad art with an instinctive nostalgia for former ways of living, of human and animal relationships and activities never to be recalled except in memory and recorded through art forms. The astounding wealth of visual motifs range through a number of themes and associations extending back from the present to the introduction of printmaking and to environmental cultural elements of virtually timeless antiquity. (3)

3. Ronald Bloore, ibid.

This process of acculturation is reflected in several ways in Inuit art, particularly in the work of an artist like Mamnguqsualuk. To begin with, the very act of drawing is a major expression of acculturation. It was clearly not a part of the traditional Inuit way of life, although it can be seen as a development of the traditional techniques of skin appliqué and the incising of ivory and bone. Printmaking is, of course, a further step in the process of acculturation.

The form of the drawings also reflects this development. Sheila Butler addressed this issue in her essay for the catalogue *Baker Lake Prints and Drawings:*

> It soon becomes apparent to any artist drawing images on a two-dimensional surface, that two equal levels of reality must somehow come together in the drawing. The reality of the everyday world environment is truly spatial, fully three-dimensional. The reality of the drawing surface is truly flat, two-dimensional. In order to refer to images from the three-dimensional world on the two-dimensional surface, some translation must be made: the image of the real world can be warped to accommodate the aesthetic possibilities and the reality of the two-dimensional surface; or, conversely, the two-dimensional surface can be warped to give an illusion of real-worldly, three-dimensional space. All artists making drawings in any place or time must deal in some way with this problem of translation.
>
> In general, our western heritage in picture-making, until the revolutionary 20th century, has greatly preferred the illusionistic end of the continuum, and non-western cultures, particularly pre-literate cultures, have tended to stress the flatness of the picture plane at the expense of spatial illusion. (4)

4. Sheila Butler, *Baker Lake Prints and Print-Drawings, 1970-76,* The Winnipeg Art Gallery, 1983: 13.

A comparison of Mamnguqsualuk's work with that of her mother, Jessie Oonark, illustrates this. Oonark had very little contact with white culture. She spoke no English and lived on the land until she came to Baker Lake in her mid-sixties. Her work was two dimensional in its orientation, interpenetrating subject and background and making little or no reference to illusions of volume or space.

Her daughter on the other hand has spent much more of her life in the settlement. The exposure to such visual material as mail order catalogues, record covers, church literature and comic books has been her visual education. As a result she has adopted many of the conventions used in the European drawing tradition to represent three-dimensional space.

In addition to a difference in form, difference in subject matter between the two artists illustrates another aspect of acculturation. Oonark did not tell stories in her work. She attempted instead to achieve a visual synthesis of symbols of her Shamanic background with the Christian values that sustained her. Mamnguqsualuk, however, as I have shown above, was one of the first and most prolific artists from Bake Lake to depict myths and legends in her work.

Bernadette Driscoll, a former curator of Inuit art at the Winnipeg Art Gallery, refers to this phenomenon in the introduction to her catalogue for the exhibition *Inuit Myths, Legends and Songs,*

> Although the stories and legends of Inuit have been recounted for an unknown number of generations, the visual portrayal of these stories dates only to the contemporary period of drawing, print-making and carving. Traditionally, it was forbidden to draw the creatures of the stories and myths: belief in the spirit world was so intense and the power of the spirits was felt to be so strong, that it was feared that the image itself would come alive. The drawing by Mamnguqsualuk recounts the legend told of the young boy who dared to ignore this precept. (5)

5. Bernadette Driscoll, *Inuit Myths, Legends and Songs,* The Winnipeg Art Gallery, 1982: 5.

The legend, in syllabics, on the back of a drawing by Mamnguqsualuk of this subject reads:

It is said, that if you draw on the ice window of the igloo,
The image that you have drawn may come to life and
pursue you in the night.
as a result, people were
never to touch
the ice window
at night (6)

6. Victoria Mamnguqsualuk, Drawing on loan to the Winnipeg Art Gallery, 1972.

Her method of illustrating these stories in her drawings is also interesting. She usually depicts several episodes of one story in a single drawing, but these are interwoven over the page in no particular sequence. So, although she has adopted some of the conventions for creating the illusion of three-dimensional space, she has not yet fully assimilated the European convention of creating the illusion of time by depicting succeeding events sequentially on the page.

The process of acculturation may create, as Bloore suggests, a "sad art", but it is helping to preserve the old myths and legends of the Inuit. And interest in these legends has continued to grow. A most ambitious project to uncover and use the Qiviuq story was undertaken in 1979 by Chris Hurley and the Manitoba Puppet Theatre. They went back to the works of the ethnographers Boas and Rasmussen who had recorded various versions of the Qiviuq legends. They went into the Keewatin region of the Arctic and collected on tape the current incarnations of the stories of Qiviuq. They then produced a play integrating hand-made puppets, mime, original score and script derived from all this material. They have achieved a level of artistic quality equal to the subject and over the last six years they have performed *Qiviuq* in many Arctic communities in dozens of performances, giving new life to Qiviuq for a new generation of Inuit children.

Inukatsik, originally, like Anguhadluq, from the Back River area, told them this tale of Qiviuq and his many wives.

I am going to speak of Qiviuq again, about the wives that Qiviuq had. Qiviuq met a female wolf and her daughter. The daughter was a very pretty wolf and he wanted to marry her. And so he did marry her. Whenever he went out hunting, he always returned with caribou meat. When Qiviuq got home the wife and also her mother would be there. The wife went to meet her husband and always carried the carcass of the caribou, most often a bull caribou. She did this because it was easy for her to carry the caribou. One time, while Qiviuq was hunting, the mother decided that she would like to have Qiviuq as a husband for herself. She murdered her daughter by pressing behind her ear. She skinned her daughter's face and put the skin over her own face and hid the daughter's body. As Qiviuq was entering the igloo, he noticed that his wife's skin seemed looser than it should be but when he got closer he recognized that it was his wife's face. She proceeded to help by carrying the carcass.

"Here is a better place to put it, there is a better place to put it," said the mother.

"You have always put it there before, so put it there now," said Qiviuq.

The woman started unpacking the komatik [sled]. Although she could barely lift the caribou she put it on the ground. This was the one who had killed her daughter to marry Qiviuq.

Every time he went out hunting he would leave his caribou socks behind on the land, pretending to have lost them. He did this so that if he decided to leave his wife, he would have enough socks. So the wife said to him, "I think you want to leave me, because you keep losing your socks."

Qiviuq answered by saying, "I am not going to leave you."
One time he left to go hunting and never returned.

He got a tent for himself. Whenever he would return from hunting, there would be boiled caribou waiting for him, and when he came out of the tent he would find that the skins had been dried. One time he decided that he would pretend to go hunting again. He hid and watched his tent. As he was watching, a fox came and he thought that the fox was going to eat his food. He kept watching, but did not come out of hiding. But the fox went walking around his tent watching out for anything that might come by. The fox went into the tent. Qiviuq thought she was gong to eat his food. But the fox came out of the tent changed into a very pretty girl. She set out her skin to dry. Qiviuq started crawling towards his tent trying not to let the fox know he was coming. When he got close enough he sprang for the skin. Just as he grabbed the skin, the fox saw him and said, "Qiviuq, give me back my skin." But Qiviuq answered, "I grabbed the skin so that I could have you for a wife."

The fox started to cry. Every time they went to bed he would use the skin for a pillow. After a while the fox got used to living with Qiviuq. When winter came they started to travel.

During their travels they came across a wolverine couple. Qiviuq made an igloo beside theirs. When the igloo had been made they went to bed, but a wolverine had come to visit and would not go out. He had suggested that they swap wives but Qiviuq didn't want to. He replied saying, "My wife is very shy and I don't want to embarrass her."

The wolverine replied, "I won't embarrass her."

When Qiviuq was leaving to go to the wolverine's wife, he told the wolverine to close the door well, and seal it well. The wolverine was agreeable. When Qiviuq left, the wolverine sealed the door and went to bed. Whenever the fox was going to bed she would flip up the caribou mattress and urinate underneath it. So tonight she did the same as usual.

The wolverine asks, "What do I smell?"

"From me, I guess", says the fox, pulling up her pants, and then she ran off. The wolverine waited for the fox to come back for a while. When he hadn't heard from her for a while, he went over to Qiviuq; he told Qiviuq that the fox had run away. Qiviuq replied by saying, "I told you she is a very shy one."

When daylight came, Qiviuq started after his wife by following her tracks. While still following the tracks he could see in the distance a whole lot of igloos. (These are actually animal dens). He could see that the tracks ended amongst the dens. Where the tracks ended he saw where the fox had gone. While standing there, a lemming came out bleeding, and it said, "I'm told that you should take me."

Qiviuq replied, "You're bleeding so I don't want you."

So the lemming went back in and said, "He doesn't want me because I'm bleeding."

Then the siksik [marmot] was asked to go out. So the siksik went and came out pretending to laugh.

"I'm told that you should take me."

Qiviuq replied, "I don't want you because you are too playful."

So the siksik went back in and said, "He doesn't want me because I'm too playful."

The rabbit was asked to go out. So it came out and said, "I'm told you should take me."

"I don't want you because your ears are too close together."

"He doesn't want me because my ears are too close together."

So the wolf is asked to go out. When the wolf came out Qiviuq wanted her because she is pretty.

"I'm told you should take me."

Qiviuq said, "I don't want you because your snout is too long", although he really wanted her.

"He says my snout is too long."

Then the wolverine was asked to go out. "I'm told you should take me."

Sooner than to the others, Qiviuq replies, "I don't want you because your snout is too short."

So the wolverine went back in and said, "He doesn't want me because my snout is too short." (There are so many animals I will just skip to the end.)

The lemming came out again still bleeding. She said to Qiviuq, "If you don't want anybody, you are to close your eyes and put your flap over your face and come in backwards."

So Qiviuq turned backwards, put his flap over his face, closed his eyes and started going in. As he is trying to get in he has a hard time because the hole is small but he keeps going in. Then he was told to open his eyes. When he opens his eyes he sees a big igloo with many different rooms. By the door the siksiks were levelling the ground by stamping, so they could sleep there.

There he could see his wife who had been crying so long that her tears were frozen down to the floor. So he went up to the fox and chopped her frozen tears, and sat beside her. When he sat down she jumps up and sat somewhere else. So he tried sitting beside her again. She does the same again. She moves away a third time, but when Qiviuq goes to sit beside her again she doesn't move away, so Qiviuq keeps her as a wife.

Now the story is ended. I am Inukatsik and I have been telling stories. (7)

7. Chris Hurley, Manitoba Puppet Theatre unpublished transcript, 1979.

And so, although the memories of the ancient spirit songs may have faded, they are not lost. Qiviuq is still alive in the imaginations of the contemporary Inuit and in the work of Victoria Mamnguqsualuk.

K.J. Butler

24

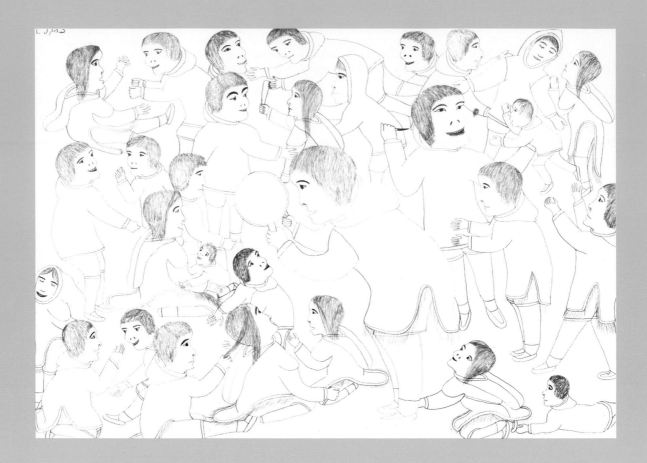

Plate 1
untitled, n.d.
graphite on paper
53.2 X 75.7 cm

Plates and Text

Plates 1 & 2

Although the large drummer is the central figure, the drawing, Plate 1, tends to divide compositionally and thematically along a diagonal from upper left to lower right, passing through the drum and the "tail" of the drummer's parka. Whereas the lower group, composed largely of seated women and playful children, is somewhat attentive to the drummer, the upper group, composed of men and women, is engaged in a number of more physical, even violent activities. In Mamnguqsualuk's work, "even subjects which relate to everday activities are tinted with violence" (Lochhead, 1979: 153). No setting is indicated here, but large social gatherings took place traditionally in the "feast house", after the autumn hunt, when the onset of the long, dark winter called for a reaffirmation of the collective identity through games, dancing and storytelling. The drawing of Plate 2 tends also to divide, but less clearly, into lower and upper groups, the one engaged in talk, the other more physically active. Both playful and serious, the clusters of figures bring individual relationships into a larger social context.

Plate 3

Without pencil or paper a few decades ago, Inuit children drew with a knife or sharp object on the walls or window of the snow-house — a pastime discouraged by mothers since the freshwater ice-pane used for a window was precious (Rasmussen, 1931: 145), so precious that it was sometimes carried carefully from camp to camp. Besides, it was forbidden to draw the dangerous figures of legend and belief for they might come to life. That is what happens in this drawing (Plate 3): the monstrous *Qayousuaq* seizes the child, defended by his mother in a series of struggles. (The drawing reads from lower left, counter-clockwise, to upper left.) Mamnguqsualuk emphasizes the cannibalistic nature of the *Qayousuaq* by giving it human form, fierce claws, sharp teeth, and a belly full of victims' heads, including that of a bear — possibly a reference to the close identity of man and bear. In a related drawing (Driscoll, 1982: No.45), the accompanying text tells that a monster emerged one night from a boy's drawing on the snow-house and "so, from then on, if anyone was drawing up against the house, this monster would show up instead of the drawing." Jenness (1922:189-90) confirmed this belief among the Copper Eskimos: the monster called "Poalleritillik" would come if one scratched on the ice-window.

Plates 4, 5, 6

One of the oldest Inuit stories, the myth of the creation of sun and moon includes episodes which, in various regions, were told singly or in partial combination as separate legends (for full versions, see Rasmussen, 1931: 232-36; Spalding, 1979: 48-63). Individually strong enough to exist alone, these episodes constitute, in serial form, one of the most powerful pieces of Inuit literature: they tell, in basic terms, of parental cruelty, vengeance and murder, guilt and remorse, trials and atonement, forbidden love and eternal rebirth. The following is a resume of the myth, with some of the more *common variants given within brackets (this practice will continue throughout the text).*

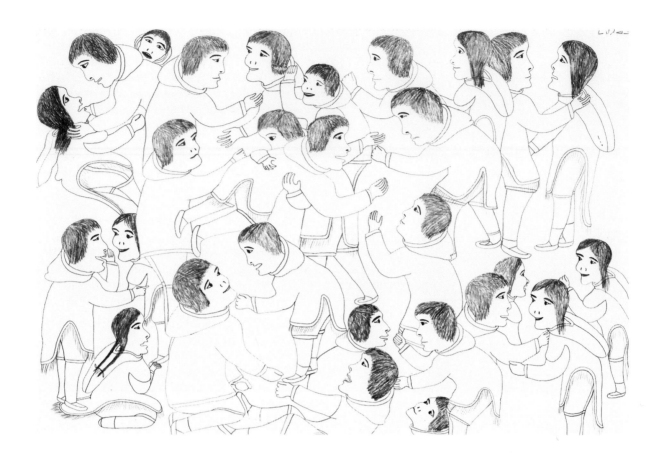

Plate 2
untitled, n.d.
graphite on paper
56.9 X 76.4 cm

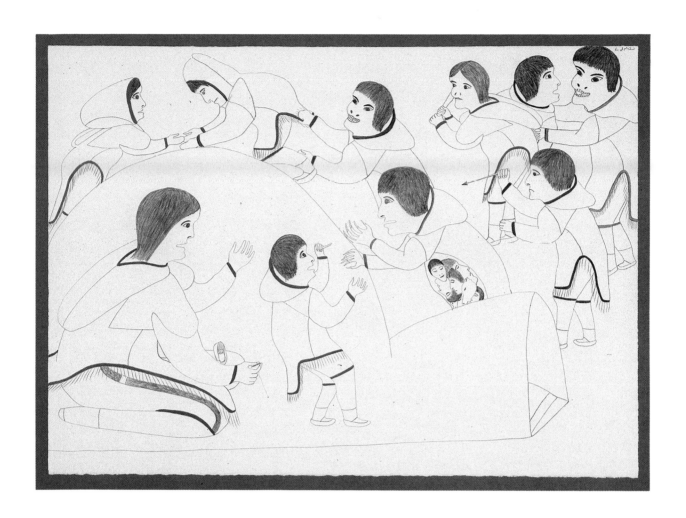

Plate 3
untitled, n.d.
graphite and coloured pencil on paper
56.4 X 76.8 cm

28

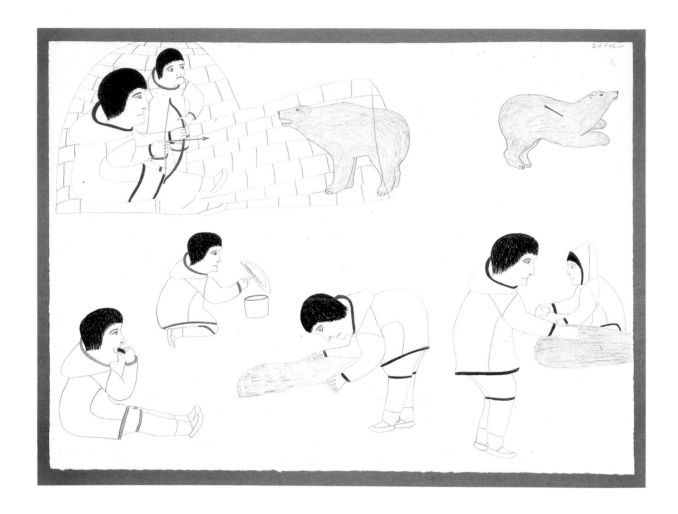

Plate 4
untitled, 1973
graphite and coloured pencil on paper
56.2 X 76.8 cm

A mother (widow/grandmother) lives with her son (grandson), born blind or blinded accidentally (maliciously by the parent), and daughter (granddaughter). When a bear comes to the window of the snow-house, the woman aims the boy's arrow for him and he shoots the bear; but the evil woman tells him that he missed (that it was just their dog) and keeps the meat for herself. The sister sneaks meat to her starving brother.

A loon (pair of loons/geese) restores the boy's sight by licking his eyes (by diving with him underwater). Seeing the bearskin, the boy knows that he was cruelly tricked.

The brother and sister take the mother (grandmother) hunting and have revenge by attaching the harpoon-line to the woman, who is pulled under the waves by the harpooned whale (walrus/seal/giant salmon). (The woman's hair, swirling behind her, becomes a twisted tusk, and she becomes the first narwhal.)

The brother and sister (man and wife) go remorsefully into the wilderness to live alone. Here, they meet strange peoples and overcome dangerous obstacles. In one of these encounters, the sister is attacked by the "long-clawed" people (long-nail/claw-troll people, by a man with long nails named Qituajung — Boas, 1888: 626-27), but is saved by her brother (the sister is killed, but restored to life by the brother/wounded and nursed back to health by him). In some versions, brother and sister settle down (and marry), while in others they come to the land of the "bottomless" ("rumpless") ones. Here, inspired by the sister's normal way of giving birth, the "bottomless" women "puncture" themselves.

One night, while everyone is in the feast-house, a man enters the sister's igloo and makes love to her (kisses her/in the husband and wife version, quarrels with her). Having marked the unknown lover's face with soot, the sister seeks him out in the feast-house: the man is her brother. Cutting off her breast in despair, she hurls it at her lover-brother and flees. The brother pursues her outside, and as they race, torches in hand, around the feast-house, he drops his torch (it goes out/she puts out his torch). Racing round and round, they rise into the darkness and are born again in the heavens as brother-moon and sister-sun (in the sky, they live apart in a double igloo).

The story behind Mamnguqsualuk's drawing, Plate 4, may be an independent, more secular and anecdotal variation of this myth's initial episode. Here, the intruding bear is shot by a blind man (father or grandfather), aided by a young boy (the drawing reads, from the upper left, clockwise); and the bear-meat likely saves them from starvation. Such a radical variation may have developed among an inland people for whom the cruel mother's death in the sea had become a foreign element, necessitating her replacement in the story. However, in other drawings by Mamnguqsualuk (Driscoll, 1982: Nos. 41, 42), we find the cruel mother who deprives the blind boy of food and the loons who restore his sight. But, again, reference to a sea-coast culture is omitted: rather than attaching his harpoon-line to the woman, the boy stabs her. A videotaped interview with Mamnguqsualuk (Inuit Broadcasting Corp., 1982) confirms that she knows both the boy-with-blind man and blind boy-with-mother stories,

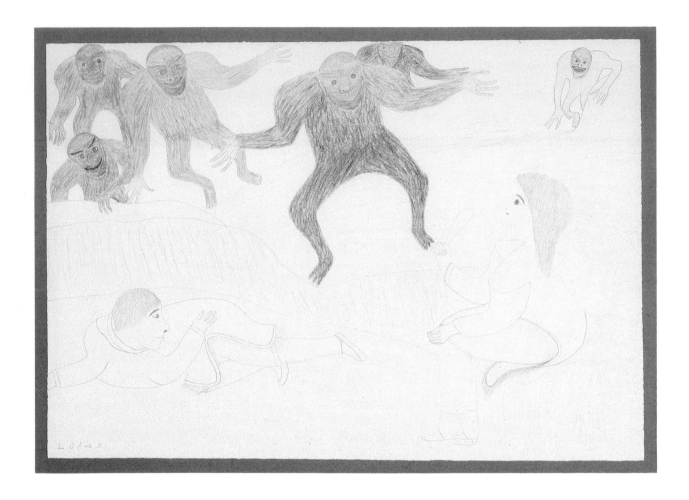

Plate 5
untitled, n.d.
graphite and coloured pencil on paper
53.2 X 75.8 cm

31

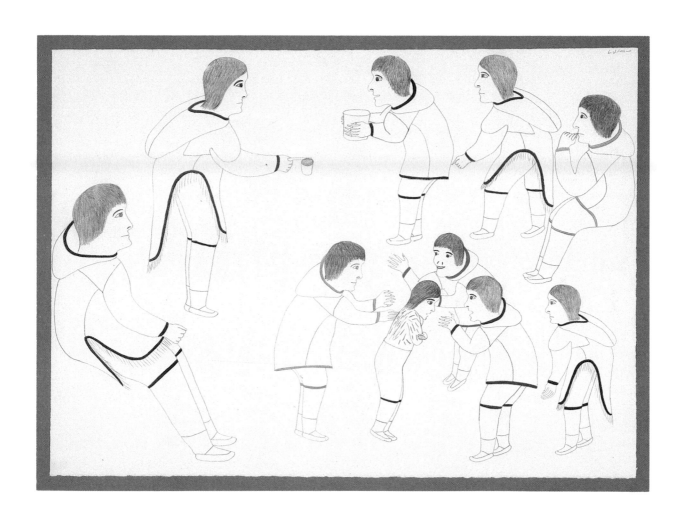

Plate 6
untitled, 1973
graphite and coloured pencil on paper
56.3 X 76.7 cm

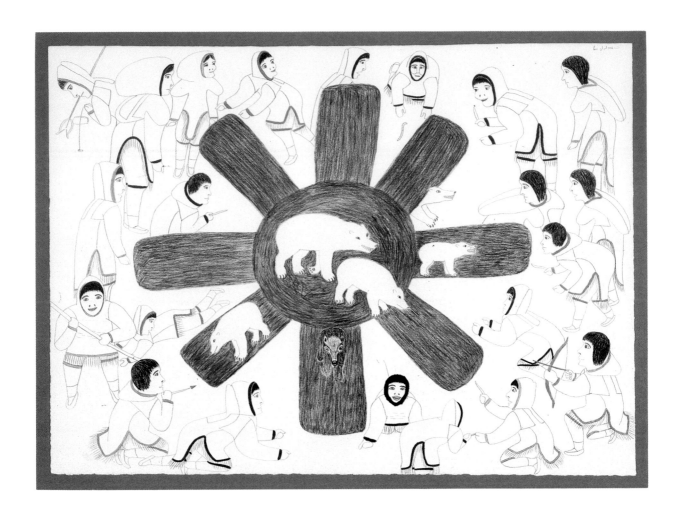

Plate 7
untitled, 1973
graphite and coloured pencil on paper
56.5 X 76.8 cm

which appear to be closely related. However, she tends to see the brother-moon and sister-sun episodes as a separate legend, although she speculates that all these episodes may be parts of the Keeveeok story; and the revenge episode of the woman who is pulled out to sea (called commonly the legend of "lumak") is not part of the tradition followed by Mamnguqsualuk in her drawings. The incestuous relationship of brother-moon and sister-sun and their ascent to the heavens are depicted in another drawing by Mamnguqsualuk (Driscoll, 1982: No. 48) and in one of her prints (Baker Lake Print Catalogue, 1982: No. 12).

The drawings of Plates 5 and 6 represent some of the frightful beings encountered by the brother and sister during their wanderings after the murder of the mother (grandmother). The four-fingered hulking monsters, with mouths from ear to ear (Plate 5), are just one of the many kinds of cannibalistic creatures in Inuit legends. The text with the drawing of Plate 6 (which reads from the left to upper right, then to lower right) indicates that this is the episode of the "long-clawed" people *(kukiligattiat, kukiligaciait, kukilialuit,* or *kukiliamiut)*. These dreadful spirits were said to live in holes in the ground or, with human form, in snow-houses. Escape from them was possible only by the strongest shamans (Rasmussen, 1929: 211). Caribou Eskimos believed that many of their people who had disappeared over the years had, in fact, been clawed to death and eaten by these creatures (Rasmussen, 1930, II: 114). This episode of the "long-clawed" people's attack on the sister appears again in Mamnguqsualuk's print "Qiviuk's Animal-Wives" (Baker Lake Print Catalogue, 1981: No. 30), but here, as in her videotaped interview, she associates it with part of the Keeveeok legend (Keeveeok's wolf-wife).

Plate 7

Both polar bears and Barren Grounds grizzly bears occupy a major place in Inuit oral literature: humans adopt bears; bears raise humans; and bears commonly assume human form. So respected were bears and their souls that they were said to know everything, hear everything (Rasmussen, 1908: 111-12). People believed also that, in the old days, bears moved underground, in winter, into dens not unlike snow-houses, as shown in Mamnguqsualuk's drawing (Plate 7). The drawing recalls an old tale told to Rasmussen (1930, II: 92-93) by a Caribou Eskimo, in which a bear, having settled down for the winter under the snow with the villagers' store of blubber, repeatedly breaks off the sticks that they push down in an attempt to locate their cache.

Plate 8

Known from Alaska to Greenland, the legend of Qaujugjut (Qaudjagdjuq/Kaujajuk/Kautahuk/Kavjägjuk/Kagsagsuk/Ahatoak, etc.) treats the popular theme of the mistreated orphan who, having grown big and strong with supernatural aid, takes vengeance on his tormentors. From region to region, details and even whole episodes of this legend vary considerably. In some versions, the puny boy's persecutors haul him about by the nostrils. Women (a mean

34 grandmother) commonly singled out for their abuse of this child, give him little to eat (only walrus hide) and make him do their most menial tasks (taking out the urine pots/pounding caribou fat). One night, the Moon Spirit (Spirit of the Universe/Master of Strength /Lord of Power) descends with his dog and sled, calls the boy outside (takes him to a mountain top) beats (whips) him repeatedly, and instructs him to lift heavy objects (boulders/a driftwood log/wrestles with him) until the runt begins to grow and his strength increases superhumanly. (In Mamnguqsualuk's drawing, Plate 8 — which reads from the lower right, counter-clockwise — the boy grows in size from one scene to the next.) To reveal his protégé's strength, the Moon Spirit sends three bears. The unsuspecting villagers put the boy out as bait (the text of our drawing says'' ''he was given to the polar bears''), but Qaujugjut kills the bears (our text says that they did not eat him), turns on his tormentors (kills the cruel grandmother), rewards the few who had been kind to him (the good grandmother), and marries the women who had abused him most. As they had beaten him, so he now whips them.

In some versions, the Moon Spirit is replaced by the visit of a giant, or a fabulous wolf-spirit, or Qaujugjut's older brother, now a shaman, who brings his ermine amulet to life to kill the boy's enemies; and additional episodes then tell of the mighty Qaujugjut's travels, exploits and adventures in the company of his shaman-brother. In a Central Eskimo variant (Boas, 1888: 628-30), Qaudjaqdjuq lives with his widowed mother until his two older brothers come home, take revenge on his tormentors, and flee with him back to their land; here, it is the brothers who whip him as he gains strength lifting boulders.

In her drawing, Plate 8, and in another drawing that treats the same legend (Driscoll, 1982: No. 43), Mamnguqsualuk has omitted all reference to the Moon Spirit, protector of the poor and homeless, and to his transformation of Qaujugjut through beatings; and, in the videotaped interview with her (Inuit Broadcasting, Corp., 1982), she states simply: ''when he [Quajugjut] grew bigger…''. Omission of the Moon Spirit, associated also with tides and marine life, would again have to be explained by his minor significance in the belief system of inland Eskimos, hunters of caribou. However, his absence makes it even more difficult to grasp the legend's moral and spiritual sense which, as is often the case, is hidden behind the story's surface action of physical violence and cruelty. It is in the figure of the Moon Spirit and the beatings administered by him that the legend's essential ideas are to be found: a superior power protects the helpless, avenges heartlessness and cruelty (Rink, 1875: 93); and, the correcting of transgressions of taboos restores life to its natural state — the beatings administered to the boy who could not grow representing the expulsion of impurities caused by his mother's or parents' having ignored some taboo (Rasmussen, 1929: 88; Holtved, 1951, II: 77).

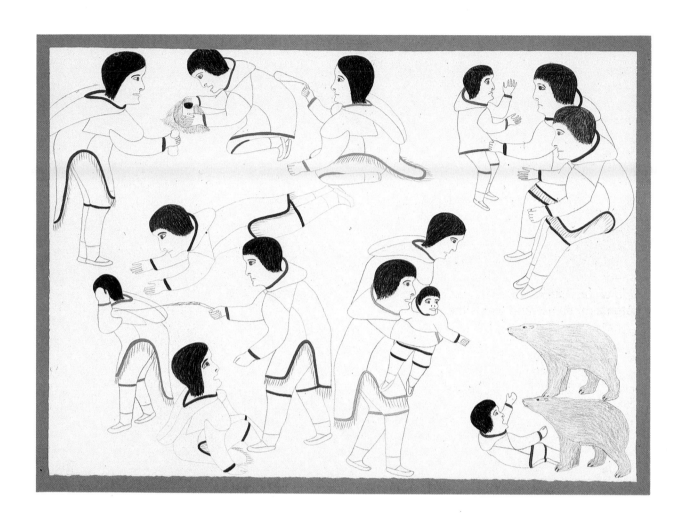

Plate 8
untitled, 1973
graphite and coloured pencil on paper
56.1 X 76.8 cm

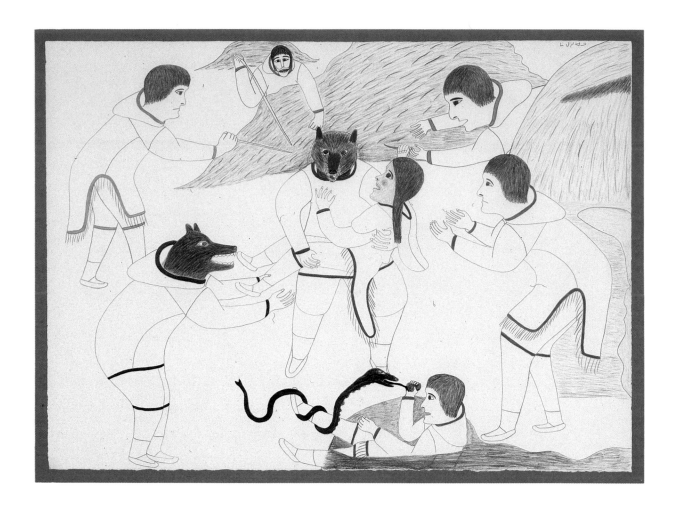

Plate 9
untitled, 1975
graphite and coloured pencil on paper
56.4 X 76.7 cm

Plate 9

Without title or text, the legend that is the subject of this drawing remains obscure. In the drawing, men attempt to rescue a woman from wolf-people; and, in the lower part, a man is locked in mortal combat with a giant worm or serpent. The drawing may, in fact, combine two legends. Numerous legends tell of humans becoming wolves, wolves taking on human form, wolves protecting or abducting humans. Mamnguqsualuk's drawing, Plate 9, may relate in part to a variation of the episode in the Keeveeok cycle where Keeveeok's wife and envious mother-in-law are said to be wolf-people ("He had a wolf for a wife at one time," says Mamnguqsualuk in her videotaped interview). Also, in one of her prints entitled "Qiviuk's Animal-Wives" (Baker Lake Print Catalogue, 1981: No. 30) wolves and wolf-people are associated with the "long-clawed" cannibal people (see Plate 6: the myth of brother-moon and sister-sun). According to Rasmussen (1931: 522), the Utkuhikhalingmiut of the Chantrey Inlet and Upper Back River area, the ancestors of many Baker Lake graphic artists, knew the story of "the man who was married to a wolf" only as part of the Keeveeok legend, but did not identify it as the episode in which Keeveeok's jealous mother-in-law slays her own daughter (however, the Netsilingmiut, to whom the Utkuhikhalingmiut were closely related, seem to have treated these two episodes as one and the same — Rasmussen, 1931: 369-70). On the other hand, the man struggling with the serpent in the lower part of this drawing appears to derive from a different legend. Snake-people and man-eating snakes (giant worms) are found in a number of Inuit tales and legends; and they figure prominently in several of Mamnguqsualuk's drawings and prints, such as "Snake Man" (Baker Lake Print Catalgoue, 1982: No. 10). In a North Alaskan tale (Spencer, 1959: 397-401), we find a good example of this subject-matter: a child is raised by wolf-people while the father searches for his wife, abducted by a man who, as a giant worm, kills those who challenge him; the husband changes himself into a bear, knifes the snake-man to death, and frees his wife. "In the old times there were many such worms.... But they say that men like this good man killed them all off. That is why we do not see them around today" (Spencer, 1959: 417).

Plates 10, 11,
12, 13, 14, 15, 16:
The Keeveeok Cycle

Keeveeok (Kigioq/Kiviuq/Kivoq/Giviok/Kiviung/Kiviuna/ Qaaweiluq) is "one of the best epic tales and at the same time one that is typical of Eskimo fantasy.... (It) contains elements that recur among all Eskimo tribes" (Rasmussen, 1931: 364). Rasmussen found that, by the 1920's, the complete cycle of Keeveeok's adventures no longer remained intact and that most tribes told a number of its episodes as separate legends, devoid of association with Keeveeok. The Utkuhikhalingmiut, however, for whom Keeveeok remained the most famous of the legendary heroes, kept as part of the Keeveeok cycle some of the episodes told elsewhere as separate legends (Rasmussen, 1931: 521-22).

Telling Rasmussen "the marvellous adventures of the immortal Kivioq", a man from the neighbouring Netsilingmiut asked:

Have you seen Kivioq? You must have met him on your travels?...Kiviok is an inuk, a man like ourselves, but a man with many lives. He is from times when the ice never laid itself on the sea up here by our coasts...from the times when there was no fog.... Later, people say, Kivioq went to the land of the white man.

And, at the end of his story, he added:

It is said that Kivioq has had many lives and that he is now at last living his last one. Formerly when he came to the end of a life he fell into a deathlike sleep, and when he awoke out of it he began a new life...he continued his age and became older and older.... And so he now goes about with his face covered up, for it is quite black, moss-grown and hard as granite. Since Kivioq settled among the white men we know no more to tell about him. All we know is that he is still alive and that before he ends his last life he will once more see the inuit, his countrymen, and his native land. (Rasmussen, 1931: 365; 376-77).

Besides linking Keeveeok to the creation of fog and sea-ice — events that are part of the episodes in the drawings of Plates 10 and 12 — this information about Keeveeok's life can itself now be interpreted as an allegory about the life of Inuit legends, their cultural renewal over the centuries and the fatal effects of post-contact history on this oral tradition.

The episode that opens some versions of the Keeveeok cycle is depicted in a print by Mamnguqsualuk, although presented here almost as a separate story (Baker Lake Print Catalogue, 1982: No. 25): a grandmother (widow, sometimes named Tuutalik) takes revenge on the people who have mistreated (her and) her grandson (granddaughter/son/who have murdered her husband) by dressing the child as a seal (transforming him into a seal), teaching it to breathe and swim like a seal, and using it to lure her enemies out to sea in their kayaks. Magically, she then raises a storm that drowns them all except Keeveeok who is protected by his amulet and shamanic powers. (A similar tale of revenge, involving a loon rather than a "seal-boy", was told by the Copper Eskimos; and an ordinary seal draws the kayakers into a storm in another of their tales which relates the next episode of our Keeveeok story — Metayer, 1973, I: 151-55; II: 361-67.)

Having drifted for days, Keeveeok comes to a foreign land, and to the house of the bee-woman — the "big Bee" (Ivigtarsuak/ Ivigtârjuaq/Igutsak/Egotajuak). Mamnguqsualuk depicts this episode in her drawing, Plate 10, (which reads from the top right down, then top left down). According to one of Rasmussen's Netsilik informants (1931: 196), the "big Bee" spirit was "ordinarily...only a common bee; but when its anger is aroused, it can turn into any form, become big and dangerous and frightful." In its form which Keeveeok encounters — that of a "cannibal troll-woman...[who] consumes her victims, leaving nothing but bleached bones" — L.T. Black (1983: 16-17) sees "an ancient motif...derived from a common source [possibly Chinese folklore] by Aleuts and Inuit...a symbol of power,

specifically the power to kill." It is not surprising that such supernatural power was concentrated by the Inuit in "bee amulets" to give "a strong head" (Rasmussen, 1931: 275), or that a shaman's helping spirit was "a bee in human form" (Rasmussen, 1931: 297), or that Keeveeok's encounter with "big Bee" was for the Inuit a terrifying story.

When, to catch her attention as she sits sewing a *kamik* (tanning a human hide), Keeveeok spits down on "big Bee" through a hole in the roof, his shadow falls over her work. Bothered by the inexplicable shadow (by what she thinks is a leaking roof), the flesh-eating "big Bee" petulantly slices off (and chews/throws into her cooking pot) her own eyelid (eyelids/ eyebrows/then cheeks and nose). Having slipped from the roof and now unconscious (invited in by her to dry himself and now sleeping), Keeveeok is saved from "big Bee's" *ulu* (woman's knife) when one of the heads of her many victims, stored in rows nearby, calls out: "Keeveeok, Awake! and flee to save your own life." This warning also provides the title of the print made by Mamnguqsualuk to depict this episode (Baker Lake Print catalogue, 1971: No. 35). Aroused in time (and aided by his helping spirit — a bear/bird), Keeveeok barely escapes "big Bee's" knife and reaches his kayak. Pursued by her to the sea's edge, he wards off her magic with magic of his own. Frustrated, "big Bee" flings her ulu at him over the water (slices a huge boulder in half). Instantly, a layer of ice (ice-floe) forms — the first coastal ice known to the Inuit — but, by drawing a line over it with his finger, Keeveeok opens a path for his kayak. Mamnguqsualuk's drawing, like the version told by the Caribou Eskimos (Rasmussen, 1930, II: 18-20), omits this dramatic conclusion in which the "big Bee's" power of death takes the fitting form of a frozen sea — a conclusion perhaps less critical for the inland Inuit whose lives did not depend on the catching of sea-mammals. It is noteworthy, however, that the creation of sea-ice is included both in the Utkuhikhalingmiut and Netsilingmiut versions (Rasmussen, 1931: 524; 367).

A close relationship appears to exist between the "big Bee" episode and, sometimes in its absence, several other episodes that appear in some versions of the Keeveeok story: the "Spider-woman" episode, the episode of the "great caterpillar" with her "meat spike" (Netsilingmiut versions speak of the two giant caterpillars and two spider-women), and that of the "Woman with the Iron Tail." The latter lowers herself (leaps down) on her sleeping victims and pierces their bodies with her iron tail. The image is analogous to that of the bee with its stinger and to that of the spider lowering itself, pouncing on its victim and stabbing it in the head. All of these episodes, involving insect-people who kill their prey with sharp instruments of death, may well be variations of the "big Bee", although the Copper Eskimos (Rasmussen, 1932: 237-38) included both the "great bee" and the "great caterpillar with her meat spike" in their version of the "Kiviuna" story; the Central Eskimo's "Kiviung" legend (Boas, 1888: 621-24) calls the woman with the murderous *ulu* "Arnaitiang" (not "big Bee"), and has our hero cast his shadow down upon the Spider-woman ("Aissivang"), who

proceeds to slice off her own eyebrows — an act more usually attributed to the "big Bee"; West Greenland Eskimos (Holtved, 1951, II: 41-46), in their "Kivioq" legend, give the episode of the woman who slices off her own eyebrow (the big bee) and of the woman with the knife-tail; on the other hand, according to Rasmussen (1931: 366; 523) the Netsilingmiut and Utkuhilhalingmiut named the "big Bee" Ivigtarsuaq/Ivigtarjuaq, but left the "spider-woman" nameless. For her part, Mamnguqsualuk gives both the episode of the "big Bee" and that of the "Spider-women" in her version of Keeveeok. However, it is perhaps indicative of the interplay between these similar legends that she treats Keeveeok's escape from the "Spider-women" (Driscoll, 1982: No. 38) in the same way that storytellers used to say that he outwitted the "Woman with the Iron Tail"; he covers himself with a stone which breaks the "Spider-woman's" knife, just as his protective stone broke the woman's iron tail (impaled her on her own appendage).

Continuing his adventures, Keeveeok meets an old woman (named Erqautdlôq — Holtved, 1951, II: 44) and her daughter. The latter's husband, a piece of driftwood (a big willow branch), dutifully brings back seals each day and, each night, makes a great deal of noise in bed with his wife. However, one day, he fails to return from the sea. Keeveeok marries the young widow. Lusting for her daughter's new husband, the mother kills the young woman, removes her skin and puts on her face. In Mamnguqsualuk's drawing of this episode (Driscoll, 1982: No. 37), Keeveeok sees through the ruse and flees. In some of the old versions, it is when the old hag, wearing her daughter's face, wades out to his kayak to unload caribou meat, that Keeveeok spots her wrinkled legs, sees her stagger under the load, and catches on (or, he flees after spotting the bones of his wife). In an Utkuhikhalingmiut variation — discussed in relation to the drawing of Plate 9 — the jealous mother and daughter are not identified as wolf-people, although one of Keeveeok's wives is said to have been a wolf; but this peculiarity is put in doubt by the recent version of this episode given by Inukatsik, a man from the Back River area (see Jack Butler's essay), where the women are, in fact, called "a female wolf and her daughter". And, at the outset of this episode in the videotaped interview with her, Mamnguqsualuk refers to Keeveeok's wolf-wife (Inuit Broadcasting Corp., 1982). Still, it cannot be clear that she sees the women of her drawing as she-wolves able to take on human form since that identity allows her to represent them as animals or as humans.

Keeveeok's escape from one or more of these dangerous women is frequently followed by his having to use all of his wits and prowess when faced with several, or a whole series of forbidding obstacles: he must race a giant caterpillar (two of them) to the safety of his kayak; paddle through the snapping shell of a monstrous mussel; slip between ferocious, fighting bears; dash between hills that unpredictably open and close; make his way along the edge of a huge, boiling pot or hop across it on floating chunks of meat; get past the great lower torso of a woman (a host of these torsos) by making love to it (them); and swing his way through an array of sealhide

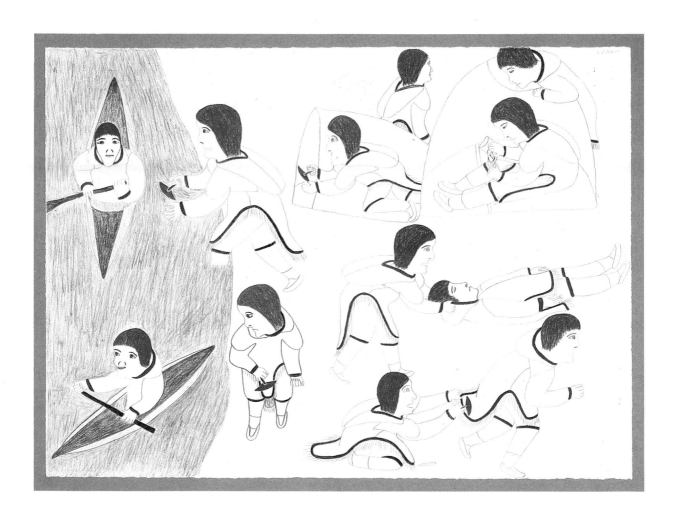

Plate 10
untitled, 1973
graphite and coloured pencil on paper
56.7 X 76.6 cm

42

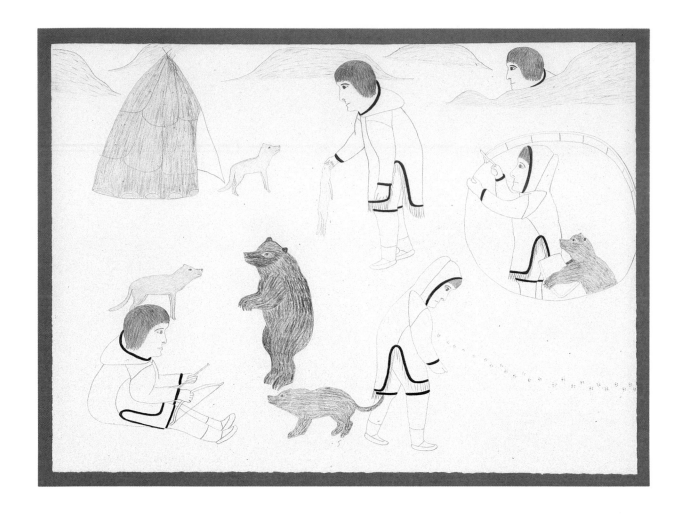

Plate 11
untitled, 1973
graphite and coloured pencil on paper
56.3 X 76.8 cm

thongs stretched over piles of human bones. A recent print by Mamnguqsualuk (Baker Lake Print Catalogue, 1986: No.14) also depicts Keeveeok's escape at sea from creatures called *oviluuq*. These brief episodes, full of thrills and suspense, may have been more fleshed out by storytellers long ago than they are in the versions of Keeveeok that have come down to us today.

Alone and wifeless, our hero settles down. One day — as the text with Mamnguqsualuk's drawing, Plate 11, tells — he finds food (and dry boots) in his tent (igloo), watches from a hiding-place outside, sees a fox emerge, slip out of her skin and hang it up to dry (she now appears as a lovely woman). Keeveeok steal her fox-skin and keeps it until she accepts to be his wife. Mamnguqsualuk's drawing (which reads from upper right to upper left, then from lower left to mid right and lower right) depicts, in fact, several more phases of this episode than the accompanying text indicates. We see also that Keeveeok and his fox-wife are visited by a wolverine and grizzly bear (a wolverine and wife/a wolf-man and wife/a neighbour/a raven). The wolverine helps Keeveeok to build his igloo and persuades him to share his wife (to swap wives). Keeveeok warns the visitor that his wife is very shy and not to offend her, but when the wolverine comments untactfully on her fox smell, she bursts into tears, grabs her fox-skin and runs off. In a videotaped interview (Inuit Broadcasting Corp, 1982), Mamnguqsualuk adds that the fox-wife escapes through a chink in the igloo's wall which its builders neglected to seal. Grief-stricken, Keeveeok follows her tracks in the hope of regaining her love. Another of Mamnguqsualuk's drawings (Driscoll, 1982: No. 39) shows Keeveeok before the igloo where his wife has hidden. Many other animals emerge and offer to marry Keeveeok, but he refuses. In versions of this story told to Rasmussen by Caribou Eskimos and Netsilingmiut (1930, II: 93-94; 1931: 370-73), as in the transcript of Inukatsik's version given by Jack Butler in his essay, we find the conclusion of this episode: Keeveeok is finally instructed by a little lemming how to slip into the den (igloo) to which he has tracked his offended spouse and there he finds his beloved vixen; spitting on his finger, he touches her so that she will not leave him again; and to celebrate this reconciliation, the assembled animals hold a song-feast.

According to Rasmussen (1931: 522), this story of the man who married a fox was known to the Utkuhikhalingmiut only as part of the Keeveeok cycle, whereas he recorded "the fox and the wolverine" legend as a distinctly separate story among the Copper Eskimos (1932: 221). In the versions of the Keeveeok story told in some other regions, the ending of this episode was not such a happy one: Keeveeok's wife decides to remain a fox; and, in some Greenland and Labrador versions (Rink, 1875: 143-45), the man kills his fox-wife. Such versions as the latter, where the fox-wife is made out to be faithless, were commonly told as separate stories, unrelated to Keeveeok, and were preceded in some regions by the story of the man who kills his wife (wives) for having committed adultery with the Lake Spirit (e.g., Holtved, 1951, II: 64-66). Indeed, Spalding (1979: 51-56) heard this story told as an episode of the Keeveeok cycle, but

its inclusion in the cycle may simply be an example of Keeveeok's power to assimilate other oral material. Still, it appears that there were two different traditions concerning the man who married a fox-wife: the one about love and fidelity, the other about faithlessness.

Mamnguqsualuk's drawing, Plate 12, tells the story, known throughout the Canadian Arctic, of the man who hid in a food cache (grave) in order to catch a thief. Whether told independently or as part of the Keeveeok cycle, whether the meat (or body) thief was said to be a brown bear, grizzly, bear-person, wolf-person, monstrous "inland-dweller", hill spirit or giant, this legend owes much of its popularity and stability to the way in which Inuit groups anchored it in their local geography. Especially when it was told as a separate story, the mountain and river created by the hero were given precise, regional identity. In the Copper Eskimo story, "The Origin of Clouds", for example, the Coppermine River is named (Jenness, 1924: 79A). That practice was maintained in the Netslilingmiut version of the Keeveeok story where, they said, Keeveeok's mountain was the long ridge running through Adelaide Peninsula and his river the "New River" flowing from the Back River country (Rasmussen, 1931: 376). The text accompanying Mamnguqsualuk's version of this legend, which she, too, gives as part of the Keeveeok cycle, omits precise geographic references, as does the Utkuhikhalingmiut story of Keeveeok (Rasmussen, 1931: 522-24), and also leaves out the usual ending in which the bursting bear provides an explanation for the appearance of fog and clouds in the world. Curiously, Rasmussen (1931: 521) included "the black bear that turned to fog" in the Keeveeok cycle of the Utkuhikhalingmiut. Mamnguqsualuk's text and drawing (which reads from the upper left, clockwise) are otherwise quite complete: Keeveeok hides in a cache to see who is stealing the meat; the thief, a grizzly bear, comes, uncovers him, and drags him away like frozen meat, but Keeveeok tires the bear by clinging to brush along the way; at his camp, the exhausted bear stands Keeveeok upright to thaw and goes to bed; the bear's wife goes out to get willow for a fire and to sharpen her *ulu* (woman's knife); alone with Keeveeok, the bear's cubs lick his nose so much that he opens his eyes and the cubs sound the alarm; grabbing an axe, Keeveeok smites the sleeping bear and flees, pursued by the bear's wife; by magic, he creates a mountain, then a large river to slow down his pursuer; when she arrives at the river-bank, Keeveeok shouts across to her that he had crossed the river by drinking it up as he went; trying to do the same, the bear drinks, and drinks, and bursts; richer by one bear-skin, Keeveeok continues his wanderings. Another of Mamnguqsualuk's drawings (Driscoll, 1982: No. 40), as well as the videotaped interview with her (1982) and a recent print depicting this episode (Baker Lake Print Catalogue, 1986: No.15) present more truncated versions of the same episode.

A more sinister episode is Keeveeok's escape from cannibals. The ever present specter of starvation made rescue or escape from cannibals, along with graphic description of their horrifying practice, a common motif of Inuit stories. Known mainly in extreme cases of

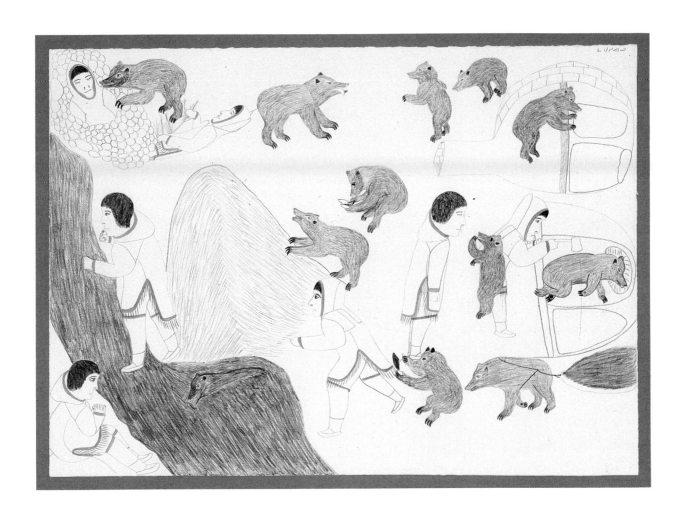

Plate 12
untitled, 1973
graphite and coloured pencil on paper
56.2 X 77.0 cm

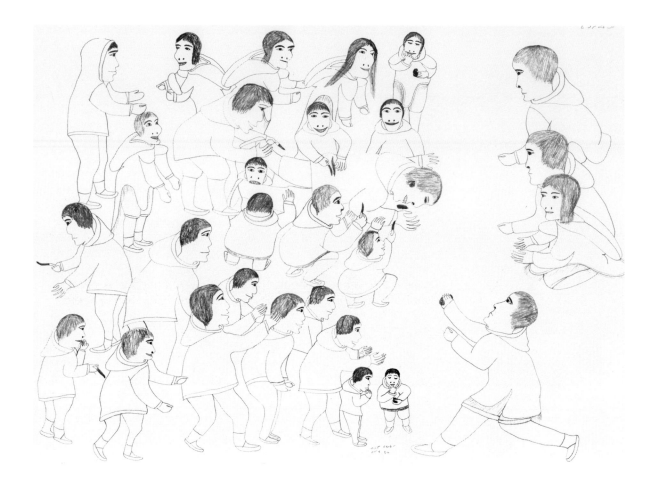

Plate 13
untitled, n.d.
graphite on paper
56.3 X 76.5 cm

starvation, cannibalism was presented as something terribly unnatural and tragic. Its consequences, especially when it involved ones kin, were said to be madness and death. The text accompanying Mamnguqsualuk's drawings, Plates 13 and 14, make it clear that this episode of the Keeveeok cycle is the same as the story of "the dangerous *nakasunnaicut*" of the Iglulik and Netsilik Eskimos and of the Utkuhikhalingmiut (Rasmussen, 1929: 291-93; 1931: 250-52; 522). This story tells of a man who arrives at the village of cannibalistic spirits with human form, distinguished by their lack of calves and shin bones and their eagerness to eat anyone, even their own people. The man sneaks into the house of a kindly old woman. She and her two sons protect the visitor and warn that he, too, will end up in the stew-pot, that his only way out is to throw a stone and hit on the ear (each ear) the biggest of the cannibals when he enters. Mamnguqsualuk's drawing, Plate 13, in the lower right corner, shows Keeveeok, flanked by the good woman and her two sons, hurling the stone at the cannibal leader. The print by Mamnguqsualuk entitled "Confrontation" (Baker Lake Print Catalogue, 1970: No. 8) depicts the same scene. Along the print's lower edge, in English, the woman's advice is inscribed: "If we kill the leader with the fleshless legs, they will leave us and not eat our people." The idea that some game is being played in this scene (*The Inuit Print*, 1977: 203) seems quite misleading. We see the results of Keeveeok's accuracy in hurling the stone in the two drawings (Plate 13: left side; Plate 14: right side): the cannibal chief's followers, including his own child, immediately fall upon their downed leader and devour him. The graphic horror of the scene explains the striking similarity of detail and dialogue in the old versions given by Rasmussen and in Mamnguqsualuk's two drawings: a child, sucking on a human bone, expresses surprise that there was fat on the kidneys of this thin father ("my father has good kidneys") — Plate 13: lower right; Plate 14: upper left.

While the cannibals feast and sleep, the kind woman advises the visitor (Keeveeok) to cut the lashings (remove the cross-slats) on all the dog-sleds, to flee, and to shoot an arrow into the ear of the pursuing dog when its rider overtakes him. In Mamnguqsualuk's drawing, Plate 15 (which reads from the upper right, counter-clockwise), the wounded dog, deaf to its rider's call, "alulaq, alulaq!" (Alullua/Aloolah: the two-headed dog's name), plunges into the water. The two-headed tracking dog of this episode is depicted as well in three of Mamnguqsualuk's prints (Baker Lake Print Catalogue, 1970: No. 8; 1971: No. 36; 1978: No. 18). Whereas she makes this episode part of the Keeveeok cycle, neither the Netsilik nor the Iglulik Eskimos' versions name Keeveeok as the man who visits the cannibal people or include the episode of the two-headed dog, Aloolah; and, unfortunately, in the case of the Utkuhikhalingmiut, Rasmussen names the legend but does not relate it. On the other hand, the Copper Eskimo version includes the two-headed dog episode, but it identifies the cannibals' visitor only as "a Netsilik man" (Jenness, 1924: 86A). It would appear, however, that Mamnguqsualuk has followed the Utkuhikhalingmiut tradition — a view supported by the statement in the 1971 Baker Lake Print

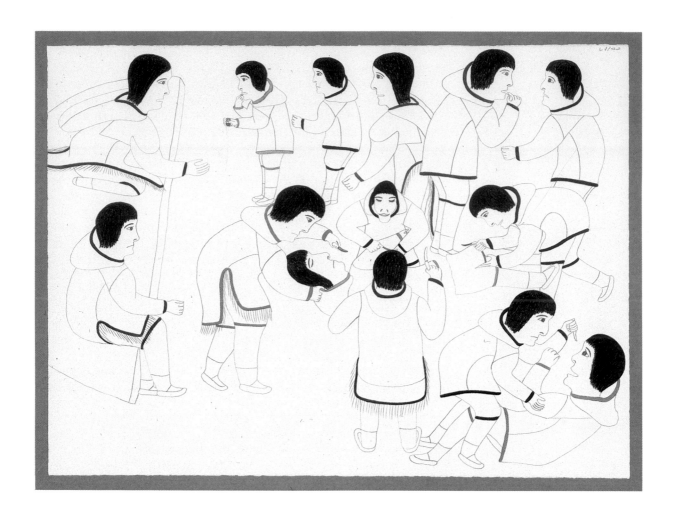

Plate 14
untitled, 1973
graphite and coloured pencil on paper
56.6 X 76.6 cm

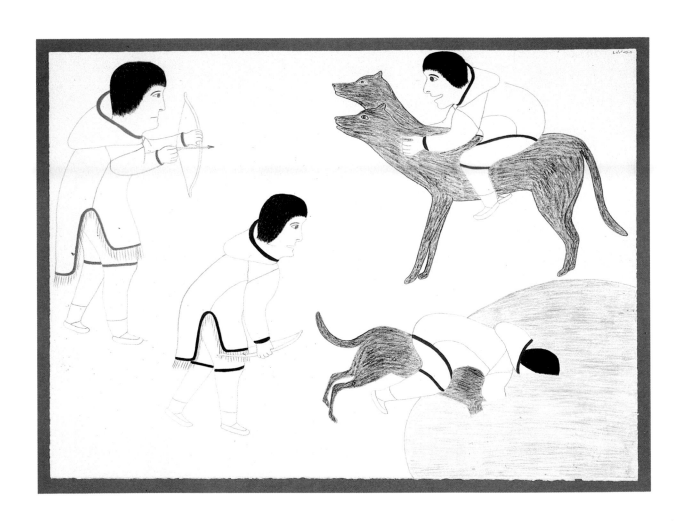

Plate 15
untitled, 1973
graphite and coloured pencil on paper
56.4 X 76.7 cm

Catalogue that old Anguhadluq from the Back River region provided the text for this episode. In his essay, Jack Butler gives an amplifed translation of this text.

Like numerous episodes of the Keeveeok cycle, those of his bird-wife and family, their leaving him, his quest for them, his meeting with the fish-maker, his trip over the sea on the tail of a giant fish and final reunion with his family have come down to us also in the form of autonomous stories, divorced from the many lives of Keeveeok. In particular, the stories of the man with the bird-family and of the fish-maker were often told separately, sometimes in combination. Boas' Central Eskimo, for example, combined the two in the story of the youth named "Ititaujang" (1888: 615-18). In the case of the Utkuhikhalingmiut, the story of Keeveeok's bird-family was included very sketchily in the version of the Keeveeok cycle related to Rasmussen (1931: 522-24), but the fish-maker story was told separately, whereas the Netsilingmiut included both episodes in their Keeveeok cycle (Rasmussen, 1931: 364-77). It may be, therefore, that Rasmussen's information concerning the Keeveeok version of the Utkuhikhalingmiut was defective. Moreover, he spent little time among these people, recorded only a summary version of their "Kivioq", and stated that he found their folklore to be "quite congruent" with that of their Netsilik neighbours. In any case, Baker Lake artists present both stories as key episodes of the larger Keeveeok story.

Mamnguqsualuk's drawing, Plate 16 — which reads from the upper left, clockwise — depicts Keeveeok's encounter with the fish (salmon)-maker, his voyage on the giant salmon's tail, and the reunion with his bird-family. Another of Mamnguqsualuk's drawings (Blodgett, 1979: No. 49) covers the same parts of the episode. This story of the creation of fish (salmon) may have originated as an Inland Eskimo variation in the Keeveeok cycle since, in a North Alaskan version of "the story of Qaaweiluq" (Spencer, 1959: 391-95), the bird-wife episode entails no quest by Qaaweiluq and, in a later part of the story, he is pulled across the sea by a whale; and, in the Alaskan version of "The Duck Wife", the hero rides on the back of a red fox (Jenness, 1924: 49A-52A). The fish-maker plays no role in these Alaskan stories. The Greenland Eskimos' "Goose-Wife", however, includes the fish-maker; but it is in a skin-boat, made from his huge scrotum, that the questing husband crosses the water (Holtved, 1951, II: 55-59).

Preceding Keeveeok's meeting with the fish-maker, we find in most versions of the Keeveeok cycle the story of his marriage to a bird-woman. One day, we are told, he comes across a group of young women bathing, steals the feather clothing (boots) of one of them, for they are geese-women (duck-women), and keeps her as his wife. The pair soon have two bird-children (a son/three children); but the bird-wife is unhappy because for food she prefers grass and sand to human food (caribou meat/ meat of sea mammals). In two prints by Mamnguqsualuk (Baker Lake Print Catalogue, 1971: No. 34; 1986: No.16), we see Keeveeok's goose-wife and children eating their usual food. Reprimanded for this by Keeveeok (his mother), the

51

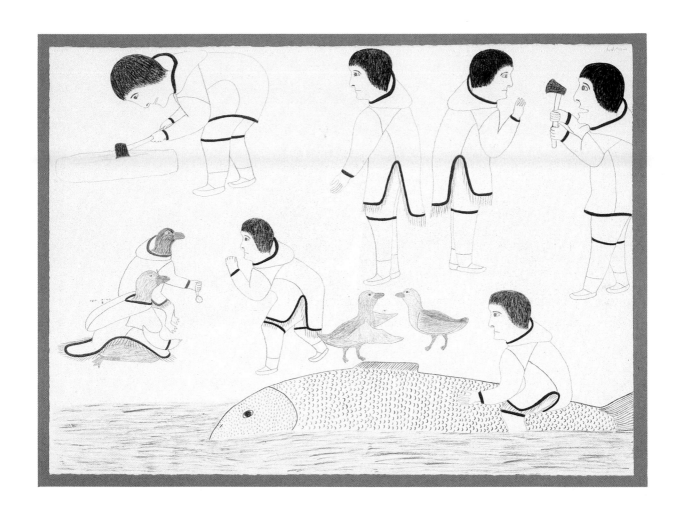

Plate 16
untitled, 1975
graphite and coloured pencil on paper
56.5 X 76.5 cm

unhappy bird-wife fixes feathers to her children's arms and they fly
off to bird-land (they fly south because it is migration time/because
the bird-wife is homesick/because the bird-wife finds Keeveeok too
suspicious a husband).

After many months of searching for his family, Keeveeok meets a
big man (giant) chopping wood, called Eqatlejok
(Ekralijok/Aningâpajúkâq/Kajungajorssuaq). With his axe this man
creates fish from pieces of wood (in the water, his wood-chips
become fish/he polishes the chips to make fish/ he brings the wood
to life by rubbing it with his semen). Keeveeok approaches him from
the rear but takes care to address him from the front (the side)
because the fish-maker is badly deformed and becomes violent (kills
the visitor) if his deformity is noticed. His unspeakable defect is that,
from backside to mouth, daylight can be seen clear through him (his
uvula hangs down from his mouth between his legs/his testicles hang
down to the ground). Although neither Mamnguqsualuk's drawing,
Plate 16, nor its text indicates the fish-maker's odd physique, they
show that Keeveeok takes care to address the man from the front.
For Keeveeok, the fish-maker creates a large fish (summons up a
giant salmon to carry him over the sea/the lake) to where his
bird-family now lives. This voyage is also depicted in Mamnguqsualuk's
early print, "Keeveeok's Journey" (Baker Lake Print Catalgoue,
1970: No. 1).

In this episode, the significance of the hole through the
fish-maker's body is unexplained; however, it is worth noting that, in
the old Inuit stories, the wife of the man-in-the-moon was also
portrayed as being hollow when seen from the rear and killed all
visitors whom she could make laugh (Boas, 1888: 599). In the West
Greenland myth (Holtved, 1951, II: 8-12), it is the man-in-the-moon's
cousin who snatches the entrails from people who can't help
laughing; and the man-in-the-moon himself, like the fish-maker,
whittles figures that come to life. It may be that, based on their
water-related powers, an association existed between the
man-in-the-moon and the fish-maker of the Keeveeok story.

Sliding off his fish on the other side of the sea (lake), Keeveeok
finds his bird-family. Thinking him dead, his wife has taken another
husband (suitor) but, for fear of Keeveeok, this fellow flees.
Keeveeok spits on his finger and touches his bird-wife so that she will
not leave again (kills her when she refuses to follow him home). This
touch of magic to keep his wife recalls a similar act by Keeveeok in
the story of his fox-wife. In fact, the two stories have an identical
narrative structure and, thematically, involve the same concern about
marital relations.

When this story of Keeveeok's quest for his bird-wife was told as
a separate tale, he commonly failed to win her back (Rasmussen,
1908: 197; Jenness, 1924: 77A); or he stayed with her forever in
bird-land (Rasmussen, 1929: 267); or he killed his trustless wife
(Boas, 1888:618; Holtved, 1951, II: 58-59). In the Keeveeok cycle,
when this quest was omitted, Keeveeok was said to have returned
home after his wanderings, where his faithful wife was still waiting
for him (Rasmussen, 1930, III: 51); or, where his wife who had

remarried now rejoined him (Boas, 1888: 624); or, where his old parents who were waiting for him after all these years died for joy, and Keeveeok set off wandering again (Rasmussen, 1930, II: 20,99). However, when the bird-wife episode formed part of the Keeveeok cycle, at least in the versions told by the Netsilingmiut and Utkuhikhalingmiut (Rasmussen, 1931: 364-376; 522-524), it appeared near the end of the cycle, but the cycle and Keeveeok's wanderings were extended into the post-contact era: having killed a man in his own village, Keeveeok went into exile in the land of the white man (where he became rich, acquired sailing ships, and sometimes visited Ponds Inlet). Although he was now living his last life, it was said that Keeveeok would not die before coming back to his own people, the Inuit.

Plates 17 and 18

In two drawings, Mamnguqsualuk depicts parts of the myth of the origin of Indians and white men. As the story begins, an old father who lives alone with his daughter marries her to a dog (the dog wins her affection/the father's thoughtless curse becomes reality) because she has persistently refused to marry any man (has changed husbands too frequently/has no man to marry). He confines the couple to a small island where the daughter gives birth to a number of dog-children (the grand-father, ashamed, banishes them to an island when the dog-husband fails to provide food for the voracious children; the old man then drowns the dog-husband by putting stones in his pack or in the boots strung around his neck when he swims back to the island with food). In his kayak, the grandfather regularly brings caribou meat to his grandchildren on the island. Seeking revenge, the daughter tells her dog-children to swim out to meet their grandfather, pretend to lick blood off his kayak, overturn it and tear him to pieces (drown him). With her father now gone and without food for her dog-children, the daughter makes a boat from the sole of her *kamik* (skin boot), places some of her children in it, curses them so that they will ever be hostile towards her own cruel people, and floats them out to sea. These dog-children become the ancestors of Indians. In the sole of her other kamik she places the rest of her dog-children and works magic over them so that they will become skilful. They sail away to become the ancestors of white men (Europeans).

In her drawing, Plate 17 — which reads from the upper right, counter-clockwise — Mamnguqsualuk shows the father in his kayak taking caribou meat to the dog-children on the island, while the daughter is shown, in a tent on the mainland, making boats from her *kamiks*, in the company of a sister. The drawing of Plate 18 — reading from the upper right, counter-clockwise — includes the scene of the mother watching from her tent on the mainland as her dog-children pretend to lick blood from their grandfather's kayak before killing him. Mistakenly identified with the Keeveeok legend (Lochhead, 1979: 151, 154), Mamnguqsualuk's print entitled "Legend" (Baker Lake Print Catalgoue, 1972: No.20) also treats mainly this scene of revenge.

54

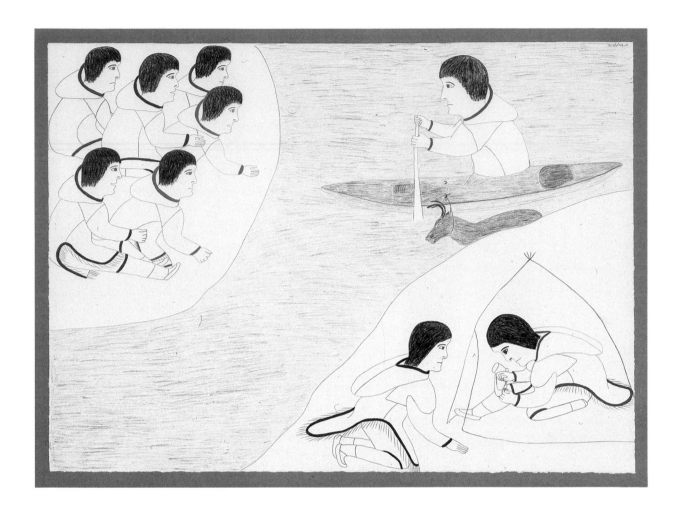

Plate 17
untitled, 1973
graphite and coloured pencil on paper
56.2 X 76.9 cm

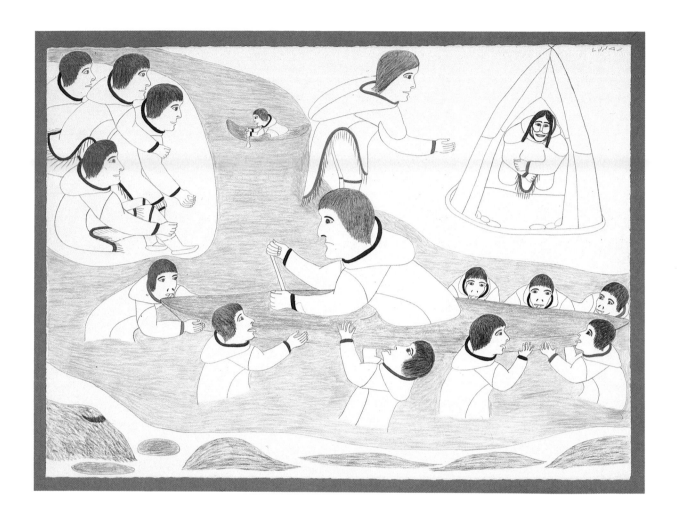

Plate 18
untitled, 1973
graphite and coloured pencil on paper
57.0 X 76.5 cm

Different versions of this myth gave various identities to the children: dogs, human-headed dogs, Inuit, white children, Indians, bears, harp seals and wolves. Consequently, the descendants of these children were also said to be of a wide variety. The broadening of this aspect of the myth may relate to its association with another creation myth, that of Sedna (Nuliajuk/Takánâluk arnaluk/Taleelayo/ Kannakapfaluk, etc.), mother of sea creatures and, in some versions, of all animal life. When "the woman who married a dog" does not herself starve to death in the end (Holtved, 1951, II: 23-26), she goes down, like Sedna, "into the water to live" (Jenness, 1924: 81A). The linking of the two stories, providing a unified creation myth that included both men and animals, raises the question of a possible common origin. Boas (1888: 587) pointed out similar names and incidents in the two myths and, in his Central Eskimo version of "the woman who married a dog" (1888: 637), the dog-children only maim the father, who gets even by throwing the daughter out of his boat and cutting off her fingers when she tries to climb back in — as in the Sedna myth, the severed fingers are transformed into sea mammals; Rasmussen (1931: 227-28) noted that some Inuit believed "the woman who married a dog" and Nuliajuk to be one and the same, and also gave an example of the linking of the two myths; and, recently, Swinton (1980:7-11) conveniently provided summaries of the various versions of the Sea Goddess myth in which its combination with the story of "the woman who married a dog" is evident. Although brought together in many of the versions of which we have record, in the opinion of Nungak and Arima (1969:115-117) the two myths were originally separate; moreover, Aleut versions of the myth of origin from a dog do not appear to have involved the creation of animal life (Black, 1983:10-15). Even though "the woman who married a dog" could later become Nuliajuk, mother of all animals in the Utkuhikhalingmiut tradition (Rasmussen, 1931: 498-99), there is no hint of this blending of the two stories in Mamnguqsualuk's version of the myth about the origin of Indians and white men.

The Inuit and the Indian descendants of "the woman who married a dog" — the latter cursed by their mother to hate her people — engaged in bloody feuds, raids and abductions, which are the subject of a number of Inuit stories. One of Rasmussen's informants (1931:122) described Indians in this way: "Human beings they are, no doubt, but not at all like us, and they speak in a tongue that we do not understand; and their customs are not ours. Yet we are distant relations, so to speak.... We believe that their character as dog-men lies not in their bodies, but in their minds and manners." Accordingly, while some Inuit stories dwell on the enmity between the two peoples, others focus on the strange manners of the Indian "dog-people."

Mamnguqsualuk's two drawings, Plates 19 and 20, likely depict the same story that Rasmussen (1931:124-25) recorded among the Netsilingmiut. In it, two Inuit, hunting inland, come across a large,

Plates 19 and 20

57

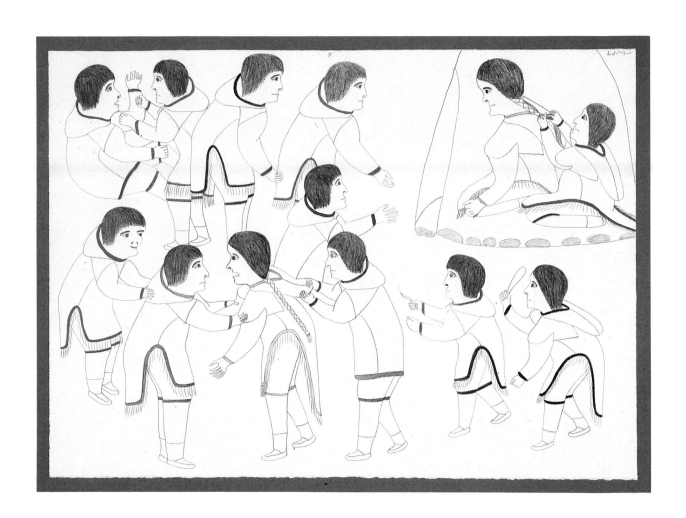

Plate 19
untitled, 1973
graphite and coloured pencil on paper
56.3 X 76.8 cm

58

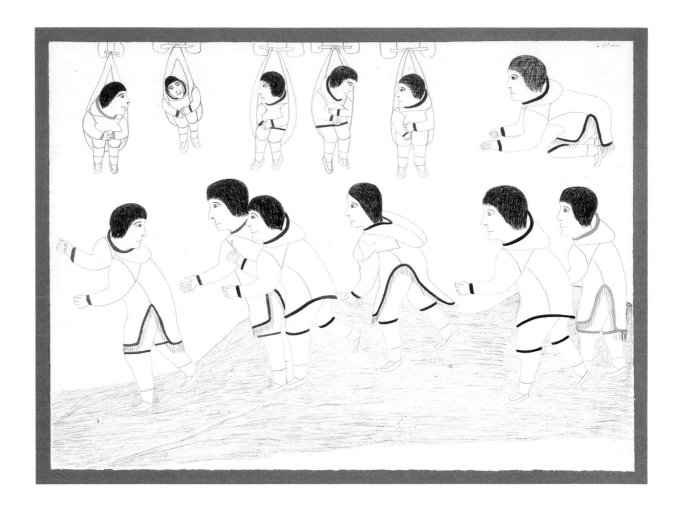

Plate 20
untitled, 1973
graphite and coloured pencil on paper
56.3 X 76.9 cm

empty Indian camp. Just as they are exploring it, its Indian inhabitants return from the hunt. Hidden in his tent by a kind, old Indian, the two Inuit watch as Indian men begin to fight, dog-like, over an Indian girl in heat. "Their love is like the dogs," comments the storyteller; and Rasmussen's informant explained the scene thus: "When an Itqilik [Indian] woman gets into the state when she wants to mate with men, she flings out her hair and runs about the village, and then the men fight for her just as dogs do"(Rasmussen, 1931: 122). Mamnguqsualuk's drawing, Plate 19 — which reads from the upper right, counter clockwise — retains the reference to the woman's hair, but depicts the Indian way of braiding it rather than its unbraiding. Curiously, too, her Indians have no distinctive clothing. The racial stereotype of Indian sexual frenzy and their mating "like dogs" appears to have been so engrained that it extended even into the Greenland legends (Holtved: 1951, II:110-12).

In Rasmussen's version of this story, the two Inuit slip out of the Indian camp at night and paddle their kayak to the safety of a nearby island from which they can keep watch. "Next morning early many Itqilit [Indians] came running to the old man's tent, sniffed round it, lifted their noses to the wind like dogs, and then followed the tracks [of the two Inuit] right down to the lake. There they waded out, but turned back when the water came up to their middle." Mamnguqsualuk's text to the drawing, Plate 20, speaks of only one Inuk and abridges the story. The drawing shows the Indians, like dogs, following the stranger's scent. Above them, she gives the earlier scene of the Inuk exploring the empty camp, intrigued by the foreign baby carriers (tikonagan) in which the Indian parents have suspended their children while away hunting. The drawing reflects both the Inuit fear of these descendants of "the woman who married a dog" and fascination with their different culture.

Baker Lake Annual Print Catalogues: 1970-72, 1978, 1980, 1981-82, 1986.

Black, Lydia T.
1983: "Eskimo motifs in Aleut art and folklore",
Études Inuit Studies 7(1): 3-23.

Blodgett, Jean
1979: *Eskimo Narrative,* Exhibition Catalogue,
The Winnipeg Art Gallery.

Boas, Franz
1888: *The Central Eskimo,* Sixth Annual Report of the Bureau of
Ethnology to the Secretary of the Smithsonian Institution 1884-85,
Washington. Facsimile edition, Toronto, Coles Publishing Co.,
1974: 583-642.

Butler, K.J.
1973-74: "My Uncle Went to the Moon", conversation transcribed
and edited by Kay Bridge, *artscanada,* Dec. 1973/ Jan. 1974: 154-58.

Carpenter, Edmund
1971: "Life As It Was", introd. to *I Breathe a New Song:
Poems of the Eskimo,* ed. Richard Lewis, New York,
Simon and Schuster: 11-23.

Driscoll, Bernadette
1982: *Inuit Myths, Legends and Songs,* Exhibition Catalogue,
The Winnipeg Art Gallery.

Freuchen, Peter
1961: *Book of the Eskimos,* Cleveland, Ohio, The World
Publishing Company.

Garber, Clark M.
1940: *Stories and Legends of the Bering Strait Eskimos,* Boston,
Christopher Publishing House. AMS Reprint Edition, New York, 1975.

Graburn, Nelson
1980: "Man, Beast, and Transformation in Canadian Inuit Art and
Culture", in *Monsters and Man-like Beasts,* ed. Marjorie Halpin and
Michael Ames, Vancouver, University of British Columbia Press.

Holtved, Erik
1951: *The Polar Eskimos: Language and Folklore,* Copenhagen,
C. A. Reitzels Forlag — *Meddelelser om Gronland* 152 (1, 2).

Jenness, Diamond
1922: *The Life of the Copper Eskimos,* Report of the Canadian Arctic
Expedition 1913-1918, vol. 12, Ottawa, King's Printer.
1924: *Eskimo Folk-Lore: Myths and Traditions from Northern Alaska,
the MacKenzie Delta and Coronation Gulf,* Report of the Canadian
Arctic Expedition 1913-1918, vol. 13, Ottawa, King's Printer.

Kalluak, Mark
1974: *How Kabloonat Became and Other Inuit Legends,* Yellowknife,
Programme Development Division, Department of Education,
Government of the N.W.T.

Lochhead, Joanne
1979: "Observations on Baker Lake Graphic Art and Artists",
Arts & Culture of the North 3 (2): 151-54.

62

Mamnguqsualuk, Victoria
1982: Interview videotaped by the Inuit Broadcasting Corporation, in conjunction with the Winnipeg Art Gallery.

McGrath, Robin
1984: *Canadian Inuit Literature: The Development of a Tradition,* Canadian Ethnology Service, Paper No. 94, Ottawa, National Museums of Canada (National Museum of Man: Mercury Series).

McNeill, James
1967: "Tracing a tale: a short study of the Kaujjarjuk theme", *North* 14 (4): 57-61.

Metayer, Maurice
1972: *Tales from the igloo,* Edmonton, Hurtig Publishers.
1973: *Unipkat: Tradition esquimaude de Coppermine, Territoires-du-Nord-Ouest, Canada,* Collection Nordicana 1-3 (40-42), Québec, Université Laval, Centre d'Études Nordiques.

Nuligak
1966: *I, Nuligak,* trans. Maurice Metayer, Toronto, Peter Martin Associates.

Nungak, Zebedee and **Arima,** Eugene
1969: *eskimo stories — unikkaatuat,* National Museums of Canada, Bulletin 235, Anthropological Series No. 90, Ottawa, Queen's Printer.

Oosten, J. G.
1983: "The Incest of Sun and Moon: An examination of the symbolism of time and space in two Iglulik myths", *Études Inuit Studies* 7 (1): 143-151.

Qitsualik, Rachel
1981: "Baker Lake Stories", *Inuktitut,* Dec., No. 49: 17-24.

Rasmussen, Knud
1908: *The People of the Polar North: A Record,* ed. G. Herring, Philadelphia, J. B. Lippincott Co.
1927: *Across Arctic America: Narrative of the Fifth Thule Expedition,* New York and London, G.P. Putnam's Sons.
1929: *Intellectual Culture of the Iglulik Eskimos,* Report of the Fifth Thule Expedition, 1921-24, 7 (1), Copenhagen, Gyldendanske Boghandel. Reprint Edition, 1976, New York, AMS Press.
1930: *Observations on the Intellectual Culture of the Caribou Eskimos,* Report of the Fifth Thule Expedition, 1921-24, 7 (2), Copenhagen, Gyldendanske Boghandel. Reprint Edition, 1976, New York, AMS Press.
1930: *Iglulik and Caribou Eskimo Texts,* Report of the Fifth Thule Expedition, 1921-24 7 (3), Copenhagen, Gyldendanske Boghandel. Reprint Edition, 1976, New York, AMS Press.
1931: *The Netsilik Eskimos: Social Life and Spiritual Culture,* Report of the Fifth Thule Expedition, 1921-24, 8 (1; 2: *The Utkuhikjalingmiut*), Copenhagen, Gyldendanske Boghandel. Reprint Edition, 1976, New York, AMS Press.
1932: *Intellectual Culture of the Copper Eskimos,* Report of the Fifth Thule Expedition, 1921-24, 9, Copenhagen, Gyldendanske Boghandel. Reprint Edition, 1976, New York, AMS Press.

1942: *The Mackenzie Eskimos,* Report of the Fifth Thule Expedition, 1921-24, 10 (2), Copenhagen, Gyldendanske Boghandel. Reprint Edition, 1976, New York, AMS Press.
1967: *Kagssagssuk: The Legend of the orphan boy,* recorded by Knud Rasmussen, Copenhagen, Lyngby Art Society.

Rink, Henrik
1875: *Tales and Traditions of the Eskimo,* Edinburgh and London, William Blackwood and Sons. Reprint Edition, 1974, Montreal, McGill-Queen's University Press.

Rink, H. and **Boas,** Franz
1889: "Eskimo Tales and Songs", *Journal of American Folk-Lore* 2(5): 123-131.

Rowley, Susan
1985: "Population Movements in the Canadian Arctic", *Études Inuit Studies* 9 (1): 3-21.

Saladin D'Anglure, Bernard
1979: *La parole changée en pierre. Vie et oeuvre de Davidialuk Alasuaq, artiste inuit du Québec arctique,* Cahiers du Patrimoine 11, Québec, Ministère des Affaires Culturelles.

Spalding, Alex
1979: *Eight Inuit Myths/ Inuit Unipkaaqtuat Pingasuniarvinilit,* Canadian Ethnology Service, Paper No. 59, Ottawa, National Museums of Canada (National Museum of Man: Mercury Series).

Spencer, Robert F.
1959: *The North Alaskan Eskimo: A Study in Ecology and Society,* Smithsonian Institution, Bureau of American Ethnology, Bulletin 171, Washington, United States Government Printing Office.

Swinton, Nelda
1980: *La Déesse Inuite de la Mer/ The Inuit Sea Goddess,* Exhibition Catalogue, The Montreal Museum of Fine Arts.

Tagoona, Armand
1975: *Shadows,* Ottawa, Oberon Press.

Williamson, Robert
1965: "The Spirit of Keewatin", *The Beaver* 296 (Summer): 4-13.

Zepp, Norman
1986: *Pure Vision: The Keewatin Spirit,* Exhibition Catalogue, Norman Mackenzie Art Gallery, University of Regina.

64 **Selected Exhibitions**

1971-72
Sculpture/Inuit: Masterworks of the Canadian Arctic,
Canadian Eskimo Arts Council (international touring exhibition).

1972
Eskimo Fantastic Art, University of Manitoba
(national touring exhibition).
Baker Lake Drawings, Winnipeg Art Gallery
(national touring exhibition).

1973-74
Baker Lake Prints and Drawings, Extension Services,
Winnipeg Art Gallery.

1976-81
Shamans and Spirits, Canadian Arctic Producers Ltd. and
National Museum of Man (national touring exhibition).

1977-81
The Inuit Print, National Museum of Man and Department of
Indian and Northern Affairs (international touring exhibition).

1978
The Zazelenchuk Collection of Eskimo Art,
Winnipeg Art Gallery.
Baker Lake Wallhangings. Gallery One, Toronto.
Polar Vision — Canadian Eskimo Graphics,
Jerusalem Artists' House Museum, Israel.

1979
Baker Lake Wallhangings, The Arctic Circle, Los Angeles.
Eskimo Narrative, Winnipeg Art Gallery.
Baker Lake Wallhangings, Elca London Studio, Montreal
Baker Lake Prints and Print Drawings, Winnipeg Art Gallery.
Baker Lake Wallhangings, Vancouver Art Gallery.

1980
Baker Lake — Drawings, Sculptures, Tapestries.
Theo Waddington, Toronto.
Baker Lake Wallhangings, Waddington Galleries, New York City.
The Inuit Amautik — I Like My Hood To Be Full,
Winnipeg Art Gallery.
Baker Lake Prints — Ten Year Retrospective,
Upstairs Gallery, Winnipeg.

1982
Inuit Myths, Legends and Songs, Winnipeg Art Gallery
(national touring exhibition).

1983
The Long Night: Drawings in black by Victoria Manngusualuq and Simon Tookoomee of Baker Lake,
The Inuit Gallery of Eskimo Art, Toronto.

1984
Victoria Mamnguqsualuk, Baker Lake Artist,
Northern Images, Whitehorse.

1984-86
Arctic Vision: Art of the Canadian Inuit, Canadian Arctic
Producers and Indian and Northern Affairs Canada
(international touring exhibition).

Public Collections

The Edmonton Art Gallery
The Winnipeg Art Gallery
National Museum of Man
Macdonald Stewart Art Centre
Art Gallery of Windsor
Indian and Northern Affairs Canada
Prince of Wales Northern Heritage Centre
Government of the Northwest Territories
McMichaels Canadian Collection
University of Alberta Collections

(Information taken in part from
Inuit Myths, Legends & Songs
[Winnipeg Art Gallery, 1982] and
Biographies of Inuit Artists, vol. 2,
Canadian Arctic Producers
Co-operative Ltd., n.d. [1981].)

66 **Victoria Mamnguqsualuk**
 untitled, 1981
 Wall-hanging, felt appliqué and embroidery on duffle
 92.7 x 101.8 cm
 University of Alberta Collections

 Mamnguqsualuk/Ruby Angrna'naaq
 Keeveeok's Journey, 1970
 Stencil
 Image: 25.0 x 57.7 cm
 Collection of the Edmonton Art Gallery

 Mamnguqsualuk/Kallooar
 Riding Dogs, 1970
 Stonecut
 Image: 7 x 7 in.
 Collection of the Edmonton Art Gallery

 Mamnguqsualuk/Pootook
 Keeveeok's Family, 1971
 Stonecut
 Image: 13¾ x 12¼ in.
 Private Collection

 Mamnguqsualuk/M. Ukpatiku
 The Boy and his Grandmother Trick
 the Mean People, 1980
 Linocut and stencil
 Paper: 63.4 x 94.0 cm
 Private Collection

 Mamnguqsualuk/Vital Makpaaq/Martha Noah
 Confrontation, 1970
 Stonecut
 Image: 34 x 62 cm
 Collection of the Edmonton Art Gallery

 Mamnguqsualuk/P. Iksirak
 Brother Moon and Sister Sun, 1982
 Linocut and stencil
 Image: 55.5 X 73.5 cm
 Private Collection